Fires Eternal Morning

Johnes Ruta

Fires Eternal Morning

Johnes Ruta

azothgallery@comcast.net

http://AzothGallery.com/

Book and cover design by Johnes Ruta, (AzothGallery.com)

Front Cover: U.S. Department of the Interior, Geological Survey.
 Topographical Map of Stratford, CT. 1965.

Back Cover: Photograph of the author at Riverrun, The William Meredith
 Foundation, Thames River, Uncasville, CT.
 Photo by Richard Harteis, 2014.
 Introduction © 2015 Johnes Ruta

Consultant work: **www.WilliamMeredithFoundation.org**
Bulk discounts available through **www.Poets-Choice.com**

"Citadel" by The Rolling Stones, from *Their Satanic Majesties Request,* words and
 lyrics by Mick Jagger & Keith Richard. © Decca/Abkco Music, Inc.; 1967.
"Matilda Mother" by Pink Floyd, from *Piper at the Gates of Dawn*, words and lyrics
 by Syd Barrett. © T.R.O. INC., EMI, Magdaline/Essex Music; 1967.
"Virgin Forest: Burroughsian Time Grid," by The Fugs, from *The Fugs*, words and
 lyrics by Ed Sanders, Richard Alderson, and Lee Crabtree. © ESP-Disk; 1966.
"When the Music's Over" by The Doors, from *Strange Days*, words and lyrics
 by Jim Morrison. © Electra Records; 1967.
"Not to Touch the Earth" by The Doors, from *Waiting for the Sun*, words and lyrics
 by Jim Morrison. © Electra Records; 1968.

Library of Congress Control Number Pending.
ISBN 978-0-9909257-6-7

Poets' Choice Publishing
337 Kitemaug Road
Uncasville, CT 06382

Poets-Choice.com

Preface

The truth concealed from the priest and revealed
to the warrior: that this world always was, is, and
shall be, ever-living fire.

Chandogya Upanishad, V,iii:7

♫ *"Haul me out of the water, haul me onto the land,*
Beneath the sky there is an open fire... "

Julian Cope: Rock song *"Charlotte Anne"*

At the periphery of this Illusion of the World
there are four cardinal doors, defended by
terrifying images called "Guardians of the Doors."
Their role is twofold. On the one hand, these
guardians defend consciousness from the disintegrating
forces of Unconsciousness; on the other, they have
an offensive mission -- In order to lay hold upon
the fluid and mysterious world of the depths, the
guardians must carry the struggle into the enemy's
camp and hence assume the violent and terrible aspect
appropriate to the forces to be combated.

Guiseppe Tucci, *Teoria e practica del Mandela*, p. 65

Dedications: to *William Meredith* (1919-2007), U.S. Poet Laureate
(1978-1980), for his kindness, brilliance and humanity;
my Mom, *Phyllis Elizabeth Ruta* (born 1924), my example in
compassion, beauty, and understanding;
Robert J. Cuneo (born 1939), retired Fine Arts Professor,
"Fra Mercurius," Magic Realist painter, and mentor;
Valeriu Boborelu (born 1941), former Chair of Painting,
Nicolae Grigorescu Academy of Fine Arts, Bucharest,
life-long friend, mystic, and Buddhist "patron saint;"
and to *Rita DeCassia* (born 1955), inspiration, healer,
and my guide in the real world...

Chapters

Distant Fires

It was still the morning of fires : the whisper of distant fires which would never stop.

This is damned silly, his voice said over the surface of the deep.

Finally his mind was speaking again, he could hear the words forming their own sounds, suspended above the vastness of everything gone, waking his attention to the pathetic, puzzling projections on the orange velvet insides of his eyelids. Pictures of past ancient weeks, beneath his weighted lids, consciously focused.

A cold gray cloud in the sky above, covering over the thought of a "Cold War," still hanging icily down from the sky.

One mid-morning in early October, Miss Brantley was giving the history lesson to her third-grade class: "Christopher Columbus believed that the world was round, but he couldn't convince anyone else. He believed there was a shorter way to get to China than the long trip through the Indian Ocean. The people of Europe wanted the wonderful spices and silks from Asia, but it was still being taught in the schools of Europe that the world was flat. Columbus visited the kings and queens of Italy and Portugal, but finally in 1492, Queen Isabella of Spain believed him and persuaded her husband King Ferdinand to give Columbus three ships to sail straight to China..."

"What?" wondered Hauberc, but two desks ahead of him, Bill flashed his drawing pad with a scribbled robot cat, and Hauberc broke out laughing. Miss Brantley got frantic, "John Hauberc, you're going to the Principal's office in ten seconds !!" That shut him up.

Then they had their "Air-Raid Drill," all of them dashing out into the hallway to crouch and cringe against the wall. But Hauberc kept looking over at the wide window panels at the end of the corridor. But they knew what it would be like – they knew there was a huge army helicopter factory, Sikorsky's, only a few miles away, some of their dads worked there – and they knew the big bomb would shatter everything in on us in a terrible shower of glass and fire, or maybe just vaporize them all in a blinding flash of negative atomic light ! It could do that, like Hiroshima and Nagasaki – even bigger.

What had happened had been so easy to see coming that no one believed it would really happen. Yet everyone had lived in its fear, knowing its irrevocable outcome -- everything sucked into the Final Conflict, like the rush at the inside of a funnel-cloud running over the long meadow of past time. The world had often come close to the edge of disaster, like just a few years before now when Hauberc was fifteen, and they took their seats on the school bus in the morning looking at each other in terror that they wouldn't be here to ride the bus home tonight. Kennedy was playing a game of nerves and "Brinksmanship" with Khruschev : would JFK get the Russian missiles out of Cuba or what would happen ? They had all prepared themselves for Annihilation. But after this approach to the brink the danger then receded -- like a great wave on a beach rolling back before coming ashore in his dream. Except "this time" it happened, and the flood tide did swallow up the shore and the inland with it. --- This was the lesson and the quiet nightmare they had lived each day -- that of ten thousand artificial suns suddenly burning up the sky ... that nothing would survive but radioactive rubble and the few survivors left in chaos... They tried to understand the reason it had really happened, but the meaning kept crumbling, even the order of the events.

"A cold gray cloud in the sky above," covering over the thought of a "Cold War," still hanging icily down from the sky. Now it really was cold and it stayed cold ! -- And the cold cloud suddenly seized its moment to fog over the Defense Perimeter on the edge of his consciousness. -- Corrosive gas wafted over and mingled in the mists

of morning, just as mustard had in the Great War, boiling away the only remaining links of sensibility holding the images together. The fearsome question, of what could really happen, had been answered, once and for all. This time the radio said it was a "Communications Breakdown," -- yeah, right -- then everything turned to silence...

The words in his head, like rhetorical static, finally faded out, just as a forest fire went raging through the hair roots of his scalp, and a rush of creaking fear : his legs were gone, exploded away!
....But no -- feeling began to seep into the veins of his extremities... The skin all over now prickled, dampness pervading everything around him. Reassured by his discomfort, he could feel how his body was huddled, stomach down, into the narrow alley between old stucco garages in an area of pleasant dwellings, the earth beneath him a frozen crevasse.

In his mind there was still something ruminating, but what was it? This area was somewhere in the East, a Central European town, the name of which he couldn't bring back into memory, looking familiar, though out of context : Occupying the corner of two streets, the back side of the nearby house gleamed an image that was strained through a mesh of rusty, waist-high wire fence, like the last image he had seen on the Distant Early Warning wall-screen display, the radar line across arctic Canada which protected the U.S. from Soviet sneak attack. (The corrosive "DEW," a fetid mustard mist that stuck to everything and warped his memory...)

But the place looked like the back yard of his parents' house in Stratford. From his earliest memories here, he was aware of the expanding universe: At first he had been allowed to play in their fenced-in yard, digging little holes in the ground, making paths across the back lawn to become imaginary roads. Slightly older, he had been allowed out of the gate, to play in the driveway and learn to shoot basketballs through the net on the garage, high above him. Then to walk to the corner and back under the nice pine trees. Eventually, he had been allowed only to explore the whole town block on which they lived, never to cross a road, but to find all the passageways and alleys between the houses and between the garages back to back, and he crawled through all the bushes in everyone's yards. The kindly ancient retired couples on the block often invited him and his little sister Juno into their kitchens and fed them sandwiches and soup, and cookies!

He and his friend Fred Pageant made the garage into a space-ship and rocketed through the planets and stars. Since a child, Hauberc wanted to be a Space-man or go and sail the South Seas. After this war, an idyllic life lay ahead of him. ... But not over seas that now boiled, in this "best of all possible worlds..." hah! Being recruited he had thought, by the time I'm fifty in State Service, thirty years in the "Future," I could become a diplomat in the Mercury Space Program... "How do you do, your Majesty? I'm Ambassador Pangloss from Earth... You must have seen all those bright flashes over there by Proxima Centura last week -- that was us ! We had a war."

"Yes," replied Xerxes, king of Prolepsis, "we're sorry for your planet..."

Everything he had learned, everything he had loved, or had hoped to find in his life, was now boiled.

Now an abandoned white house across its spacious neat lawn, like the one where he used to live, now contained the same fragmented boxes of motionless activity.... Silver-anode eyed bodies peered back at him through their un-blown-out windows -- His mother glared out impatiently at him from one of them... (Like every other middle-class suburban community in the world, this town was now merely one plot of the vast above-ground cemetery.)

Dim, hazy gray pressed in. Something was still sticking into his side, between himself and the broken-shingled garage wall, and forcing a deliberate movement, he reached down and pulled it forth:

US ARMY AR-15 CARBINE.

A broken relic, it was his own now, without meaning, except as a useless toy. There were no enemies, nor any friends, nor any neutral parties he had seen for some time. Strategic Command had toyed with the scenario of this disaster for so long, had programmed for every contingency, that now there was nothing left

to do. How could he get back to America from here? Was he the Last Man, the opposite of Adam? Was this like the Big Bang itself, detonating a second time, the blast spawning a Second Universe? He would have to wait millions of years for another human being to appear --

Perhaps he would be God himself --

if he didn't feel so dizzy, if he didn't feel as though gravity was working sideward, pulling him into every object he looked at; Death tugging at Life...

Strategic Command no longer signaled his covert directives... He tried again to remember the Contingency Plan, tried to focus, but amidst the weighted horror of images, the thought passed, and his mind re-flooded. Separating from shore, the radio drift became uncontrollable / "Frequency drift!! I can't lock onto his signal! Oh, God, we're losing him !"

That was the last : a deafening squawk.

prolepsis 2

"We're ready tonight." An unwavering, lost, sober voice, that came up from the depths.

Abrupt jell.

Small, dark, empty room, five young people, Westin, Ansgar, Opal, Frederick, and John, as they called him here, sitting on the floor in a circle, around a blueprint of the Communications Reactor. Opal, his friend from high-school whose parents were Russian emigres, had left art-school after a year, and taken courses for Electronic Communications, and had worked at the phone company and now here. She had "borrowed" the blueprint.

"Are you sure the device can't fail?" his own mouth bubbling, vocal chords vibrating.

"By tomorrow evening, every government in the world will be temporarily paralyzed," Ansgar replied. "Temporarily--until our ultimatum is met-- that is, until they stop governing----"

Blur of

scenes flashing by, dissolving into streaks: red,

yellow, blue, orange, green, black.......

Running with the others. Through pine grove, nocturnal silver-brown rocks and erect grass-blade shadows..... Opal led them down a security entrance into the underground complex, the steep metal steps scratch/clanking beneath his boots

.....and down

into the brightly lit fluorescent corridor, walls wearily sighing with the flow of the senseless motley of young freedom-fighters they called "terrorists."

In the adjacent computer-filled room, another iron-rung ladder leading up to the Communications Reactor above was besieged by a forest of adolescent olive-drab camouflage trees. This Pandora's Pan-Opticon system which maintained total surveillance, monitoring

every conversation spoken, every letter written, scrutinizing every word on the planet, must be sabotaged.

--But guards suddenly appeared, using their rifle butts to hack their way through the thicket of saplings.

Hauberc thought he must be dreaming, recognizing them as two teachers from his high school, wearing guards' uniforms : short, intense Mr. Read, the English instructor; and old, energetic Miss Wheeler, the eccentric science prof -- tall, thin, and wiry.

Read, grammarian and authoritarian more than teacher, advanced through the swarm, but Miss Wheeler recognized the Natural Biology of the situation and casually turned to leave the room.

Halfway up the monkey bars, Hauberc watched as R_ead_ shoved forward and thrust himself up the ladder in hot pursuit. Arms and kicking feet snaked through the tangle of metal.

But the pulling at John's foot suddenly relaxed as R_ead's_ pallid body slid inert back into the open-armed motley below.

"Don't hurt him, just get him out of here!" Hauberc shouted down. "What am I doing here, anyway? I'm agent-provocateur," he said to himself, though there was something in him being satisfied by this membership. And this was what Simone wanted him to do. ...But suddenly, almost to the top, the ladder negligently pulled out of his grasp, allowing him to topple to the floor as well. With the sirens wailing as if nuclear attack had been triggered, the floor itself was oscillating somewhere between the ceiling and the walls. But his

magnetic talons managed to clutch hold again, his arms waving at the maniacal, deafening, ultra-red spotlights...

Following the rivering glacier of adolescents, he passed the dead R<u>ead</u> (mr) sprawled on the kindergarten floor. No phrases of pity or feeling came into his head -- the Death *Sentence* was only an APHASIA of words in the *oblique diagrams* of meaningless sentences. Only his facial muscles grimaced at the sight, acknowledging the immense scandal of his situation.

Down the corridor in a lobby-like area, the same inert teacher was also lying on a wheel stretcher which had been bumped out of the way. Hauberc ambled over and loosened the bonds so that the teacher could escape before the building blew up. Read's thin lips smiled up in gratitude but his Empty orbs stared at Hauberc, broiling him beneath his jacket.

"Look, I <u>said</u> 'Don't hurt him'!" he argued to convince the corpse to quit bugging him. "Oh--go t' hell!"

Fed up with everything, he turned and trailed after the ebbing glacier of children.

Now Hauberc wanted to write a letter home, the thoughts ran through his mind in streams of words to say to everyone at home, and the feelings and memories ran through his body like something electric had made a short circuit, from his nerves to his brain-cells. He wanted to write to each one he had loved before. He hoped they still lived, he prayed they had survived.

Dreams of each one possessed him, one after the other, as if they had come into his life. But he wanted them back all at once, especially if he had died, or was about to. He wished that communication would be granted again. All these memories came back to him, out of order.

There was no really solid ground for Hauberc to walk over these memories, to review the continuity of his life up till now -- all like a path of broken ice flows separating from the glacier of Time which were laid out before him to jump across where he could ford, or wait and dwell where the gap was still too wide. Each ice flow of memory formed another part of the jigsaw puzzle of the massive ice-shelf, another fragment of the series of events peopled with the recurrent faces of childhood and those who had led him -- until the disaster had left him on the strand, beached in an unknown but familiar town: Images of walls, doorways, and trails strung together in an amnesiac cause-and-effect of what was inevitable.

Walnut grain finish on formica, the walls in a small elevator compartment.

Sensation of falling, falling into the Before Time. --- (The time before the disaster had overtaken the Cold War rivalry now was eclipsed by the eruption of fireballs, becoming the exclamation-points of history.) -- Hauberc's stomach was pitching around in his abdomen, the elevator enclosing a universe soaring skyward in its shaft, and he woke with the cold of gunmetal in his hands.

The lift abruptly jolted, his stomach sent careening up into his rib-cage, thrusting his heart into his throat..... The lift's gates suddenly slid open, blasting sunlight into the elevator compartment, flying splinters of rays, splinters of rage, into the troopers' young faces, bathing the whole compartment in a blinding light.

Immediately he was repulsing khaki-clad figures with conditioned antipathetic mutterings.

Upon an architectural network of twelve-foot wide open sky-bridges, connecting lofty glass-and-steel office balconies, a cacophony of sporadic gunfire and popping laser-weapons striking flashes all around him.--- The concrete railings provided the only cover : There had come a sudden alert to his unit, sounding shocking and stupid: Invaders from the "Prolepsis Nebula" were descending from a floating fortress. The real Top Secret reason for NATO's

elaborate Missile Defense Shield became suddenly obvious. These were not Earthly soldiers.

Yearful hours of fighting passed without reinforcements, until the defending force had reached complete physical exhaustion, streams of blood mingling with the pea-soup atmosphere. And finally, he was rushing to escape the carnage of strewn bodies, rushing across the latticework of sky-bridges to find one remaining undamaged elevator...running around the corner of the building, colliding with

Boxes. Crates

of unused laser guns :

like unmanned armies,

sitting next to the elevator door.

The person standing there was a little green invader, blocking his way. He looked like someone dressed in a snot costume, yet somehow human....

Scared beyond thought, Hauberc sprinted to an elevator he saw undamaged by the blast; ran to the shade.....rushing for cover! rushing to escape bullets as well as insanity, bullets as well as *hopelessness*, and then he thought of Persephone.

The *pin* of the grenade was already pulled, held close within his hiding place, the catch released and he

Waited, waited

(Elusion)

Still <u>disgusted</u> with himself, his mind attempted to flush everything that had already happened. How did they know that these were alien troopers, as his unit had been briefed?

Was this a loyalty test? The clock was running out for any more questions...

But the *red-violent* hue of the morning's prologue again enveloped the world.

Anxiety. (The hell with these

Melodramatics---)

He instead let the grenade slide down the outer surface of the battlement, where it blasted a chunk of concrete that glanced off the side of his head.

prolepsis 5

Low-yield photon shells and neutron-radiation had taken a sizable toll on the area, especially in the part of Stratford that lay south of US-1. Most buildings still stood, but as little more than hollowed halls.

crates in crumpled five foot high piles by the unloading dock of the suburban store were good cover from stray bullets.

He couldn't understand why it had happened so fast though. One short-circuit in the Communications Reactor had blown the whole scene into complete pandemonium. When they couldn't pick up BBC or Radio Moscow, that was finally definite -- since then the radio waves were completely blank. How the hell had he gotten back to his home town? He realized that he was walking from the direction of Stratford airport in the south end of town, but it seemed like he hadn't been too conscious for miles or days, if he had been flown across the ocean. The transport plane had landed on the runway, let him out wordlessly, and taken off again. The others barely had looked up from their kips laid out on the cabin floor.

Even the radio communications shack had seemed like the den at home where he used to listen avidly to the world day and night.

Early morning sun was not yet risen above the drab white-cloud ceiling, but shone yellow on the white-washed side of a building.

He was kicking his way through the rubble, discarded cardboard and wooden delivery crates. Less than a mile yet to walk, he was still not yet home, when an older voice turned him around to a man leaning by the Meat & Produce - Night Delivery Entrance.

"Hey there, son. Where're you going?" The man was holding a rifle pointed at him.

"Hey," he flipped back. Who the hell was calling him that..?

23

"You live around here? Don't I know you?"

Someone was keeping a vigil, an even tone of voice, not much older than he.

"Yeah, up the stream by Brewster's Pond ...I was stationed in Europe and I haven't been home since Before...John Hauberc." (He decided not to mention "military intelligence" or "CoIntelPro.")

"Oh, yeah...OK, I remember you -- little Johnny Ho-berk." The face was more at ease, though not yet trusting, while more vigilante-militia types suddenly arrived in two dusty and dirty automobiles, still with fuel, and crowded around, blindly muttering like good-old-boys, about what excitement was up for the afternoon. "How did Europe come through this ?"

"They're fucked too."

"Hey, Ho-berk," another quizzed, "you know anything about these subversives still hiding out around the college.? " His blank expression held their attention a moment a bit too long for him.

"He's OK. He was military," the first accoster put in.

Blood-thirsty unrest was growing. "OK you guys, let's go over the University of Bridgeport and see what we can stir up from the rats' nest."

"*communistsqueersbeatnikpinkoanarchists*"

The group and their rifles had soon jumped into their cars again and gone racing across the wide asphalt plain.

Coming upstream, Long Brook Park still looked intact, the trees standing, and the old-fashioned horse-shoe shaped gravel-bottom pool where they swam as children, still pretty. But walking north up Charlton Street hill out the other side, where the houses on the left side overlooked the woods and field on the right all looked abandoned or evacuated. Only a few hundred feet to go... then into his driveway and back yard ... and up the back walk of his family's house. Heavy Rain drops were beginning to thump the dry earth.

The back door ajar, he pushed it in softly and walked into the back hall -- the notes left on the side stovetop already visible in the kitchen ahead...
.. a heart-in-throat eternity of four or five steps ---

"John and Juno, Why aren't you back yet? --- I cant keep going like this.. Seams of the world are falling apart, I'm so sick --- Must be the Radiation sickness now ---
Love, Mama "

There was nothing from his father except in Juno's handwriting :
"John, if you ever read this, Daddy went for help for Mom when I came here yesterday morning. He said to wait here but its too late. I'm heart broken, he thought I was already gone -- he couldn't even see me sitting in the chair. Can't stay here anymore -
Love Always, Sis

"No more bones or people or Rival or Cycle Two.
Very Sad. Good-bye.

 Love,

 O O

 O O

 ooo RUFF

Hopeless pools were before his eyes as he stumbled through the dining room and out onto the screened terrace.

The other houses on this shady corner of Laughlin and Charlton looked the same. "If only I had come back sooner," he thought, she wouldn't be gone too. (He had thought of how he had left her alone to contend with their same non-sense; but she had always adapted so well).

Now, no one, nothing but despair. If only to see her face.
Under a threatening blackening sky outside, a mild gust rustled through the trees, bouncing between upturned silver-green leaves... falling to utter calm in attendance to the approaching deluge.

Up and over the step / escaping the thunderhead fallout storm back into the house, back through the living room, over the stair-case landing, around into the kitchen again -- but a noise. the sound of muffled whimpering from upstairs; and he ran up the down-speeding

escalator, up to the summit and left into a pink garden room of light perfume and peacock feathers) to sister (who turns around from looking out the window, as the large drops thump the windowsill).

prolepsis 6

Tomorrow, he walked up Laughlin Road, shuffling through the upper field of Brewster's Pond, up Plymouth Street, and out into the Paradise Green shopping district on Main Street, all the stores looked like they were only closed for a holiday.... He hiked slowly north up Main a mile, and branched west onto Cutspring Road. There was something else he needed to know...

It was the next afternoon, the sun shining again almost normally, but still an aloneness of desperation. He wondered whether there were any others searching the town, faces he could trust from his childhood besides those armed vigilantes prowling around.

He wandered out of his delusion, with some sense of hope, reflective images skirting across his memory. This was a pleasure walk route he had taken often with Persephone, passing through residential streets of modern Colonial style homes separated from each other by wide well-kept lawns with no sidewalks on their edges... The road skirted the base of a wooded ridge on the left, where streets with names like Wigwam Lane and Anson Street came down the hill. To the right, further out past the modern split-levels, the scenic fairways and greens of a country club golf course sprawled out to the north.

The green stucco house up the hill on the left was Persephone's parent's house, the Richardsons./ It seemed now that "virtue had been rewarded," she at least could have gone to heaven in a state of Catholic grace... Still, he wished he could simply go to her house and find her there, and take her in his arms, but it was impossible.. The futile surge rising in his chest was sweeping through his entire consciousness: As much as they both had felt the intensity of love, she had never let him say it or show it, and they had hovered on the verge of consummation, before/ Now there was only emptiness -- now he could never tell her how strongly it had lingered since their separation -- Now at NYU, her last letter, sent before his U2 mission, but received days after it, mentioned someone new in her life, "a really brilliant chemistry student" at Brooklyn Polytech.

He had dreamed of her promise to come and meet him in Madrid. -- But a submerged glowing-cobalt zone of total ocean stillness in the wavy deep blue Bay of Biscay, visible from his U2 surveillance plane high above the north coast of Spain -- had engulfed that dream into the depths, the depths of despair.

prolepsis 7

All night moths had crisped themselves on the white-hot pencil-thick spotlight filament outside, sending up milky billows of smoke.

Foggy grayness was once more pressing in :

Everything in the small, first-floor den of the safe-house was yet intact, perhaps mummified, in the stifling room, unventilated with its windows shut.

The sun still made its daily watchman rounds over the dead planet.

Crackling on the array of short-wave radio receivers/ static of the outside world--- Back in this fucking listening post, recovering from his head wound; a desperate aloneness pausing and waiting for reply from anywhere beyond this room. They disguised their identity with the plaintive radio amateur call "CQ? CQ? calling CQ....."

Da-dit-da-dit da-da-dit-da tapping on the code key.

Seeking anyone *Seek You...* ?

Half-closed venetian-blinds cast diagonal patterns of fuzzy sun rays across the pink walls and shelves of the large radio rig. But there wasn't one radio signal to be heard over the air.

"Try the twenty-meter band," the second operator urged. In a dream, before, it had been his sister sitting next to him when they were children; now it was the slightly buxom "Opalescent," now a communications expert, who always seemed to forget the top three buttons of her khaki shirt....

"I don't think it'll do any good, but --" His hand slowly twisted the dial 12000 khz 15000 khz 11000

nothing

No Strategic Air Command Single-Side-Band, nor

Radio Moscow, BBC, nor ---

--- breaking through the silence, suddenly, -"Pine Cone, Pine Cone, this is Fig Leaf "-

"That's him!!" Hauberc flicked on the transmitter.

Something was finally coming through.

They began to hum as forcefully as they could, to make an audible carrier-wave, until the room vibrated with power. "Fig Leaf, Fig Leaf, this is Pine Cone, go ahead."

-"...Cone, Pine Cone, this is Fig Leaf, come in please."- They hummed again, louder. But their emulation seemed to have no effect on Fig Leaf, he wasn't even listening.

"Why won't he answer?" the second operator asked.

"I don't know but he's gone."

His hand rotated the band selector, tuning to lower frequencies ... 2182 kHz. (Marine Distress Band.) ...880...540...432...363... till the wavelengths stretched out to infinity...

A Tremor of terror and suddenly he awoke in bed in the middle of the night, his eyes still closed in the dark of his parents' house. There were still these slow Seismic Vibrations, a rumble winding down to slower than one wave per second, the Earth tremor's rhythm rumbling the entire house, unsettling the darkness; now indistinguishable from his heart heavily beating. In the split-instant he had awoken, he thought he had heard a muffled female voice like a coo, and wondered if it had woken his parents in the next room too ? -- But nothing more; and his next thought, while his eyes were still closed in the inky velvet, was that the vibrations were generated closer, like in the dark of the next room. Stopped and restarted, like

31

someone waiting for him to fall off into sleep again …

Modulation crackle, like a signal transmitted from mind to mind, "Fig Leaf calling Pine Cone, come-in please," an authoritarian voice in his head like his father's or his commander's "You must tune your receiver out of the low frequency range, Pine Cone. You're not supposed to be monitoring this wave-length. Tune to higher frequencies !! <u>You're not old enough yet</u> ---"

 waver

 and fizzle and he slipped in again,

 Frantic dial 2300 khz ... 2500 ... 2800 ...

3200 ... 3800 ... 7500 desperate

frantic points of infinite wavelengths on a parched yellow radio dial of dream were sliding away, now totally dead.

And then the soup-thick gray fog swept onto the bare-footed beach.. Nearby friends became Blurs became Shadows became Fossils on the steep sandy slope.

In staggering blinded steps --

 contact was lost, until, he felt the sudden searing pain through the sole of his foot:

Glinting in a shrouded shaft of sunlight, the strait pin he had stepped on protruded from the tender bottom. He lifted his foot and carefully pulled it out, but solenoids flickered within the wound.

And the heart inside him Pounding Squishing Throbbing,
hammering the beach into wakefulness
 The blood between the warm bedclothes,
roaring through firehose veins. "Dead, death.
This is *it*."
 and the surf crashing, breaking out of his chest
cavity.
 "I'm dead, but I accept it." And the luminous
night-table clock hands were yet moving,
so slowly.

Topography

prolepsis 8

Ten months earlier and at twelve miles altitude over the north coast
of Spain, a green line divided the land from sea. Below him, over
the long wings of the airplane, the vast bright blue Bay of Biscay
stretches to the north over the horizon ...

The memories keep streaming past his eyes, and there's no order in time. Some of these scenes even must be coming from other people and even from other times in history? Could there be something like "genetic memory," like memory buds from his parents and grandparents?

Still with child eyes, he had been looking out through the bushes / over silver-bird wing tips, off the edge of his yard, down through the stratosphere, over continuous ripples of bright steel-blue ocean stretching out sideways for miles, wave tips glistening in the sun like tiny diamonds; the green east-west irregular edge of land widely scattered with coastal Spanish ports far below him; towns nestled deeper in the hills of Cantabria; and other villages far off to the south...

Assigned with a U2 reconnaissance mission, on orders directly from General Simone, they were just slowly floating, at near sixty-five thousand feet in non-hostile airspace, where he has been monitoring the infrared sonar screen to search for the B-52 that went down two days ago with live Hydrogen bomb warheads, gone underwater with all its flightcrew aboard.

Because of the danger, he had telegrammed Persephone to delay her flight to meet him in Madrid; but his message had arrived too late, and though they hadn't talked for almost a week, she was already on her way across, on a transatlantic flight. Somewhere, perhaps twenty-five thousand feet below this altitude, her airliner should be passing about now, and they would soon be running naked together on an isolated stretch of shining beach down on the Costa del Sol. So long apart..

But her plane still hadn't come.

Lost : At the Madrid Airport, he waited in the terminal for her flight which would never arrive.

Now they had lost both the H-Bomb and the plane she as on. The U2 motto *"Videmus Omnia"* kept ringing in his head, over and over, and he adds to it, *Nihil Autem Gnoscimus!* "But-- We Know Nothing!" Why hadn't Persephone told him sooner she was coming? given him more notice to expect her arrival? This was now the inevitable (and irrevocable)

waiting;

-- Her missing plane now with their bomber -- both on the bottom of the Bay of Biscay somewhere off the north coast of Spain below ?

--- And there he spotted it below, a submerged glowing-cobalt circle of total stillness in the middle of a wavy, deep blue ocean ---

a zone that engulfed that dream into the depths, the depths of despair.

Waiting to explode into sunlight together, wondering ".....God, Love, where are you?"

The fear hits him like a sudden bomb that something else has happened, and now his own plane suddenly bursts apart around him the empty air pulling him toward the distant ground, plunging him down in free fall from sixty thousand feet -- tumbling down off the edge of the back-yard hillock through leafy branches of bushes --without parachute or goggles...

In the busy harbor of Istanbul, he remembered the bay waters of the Golden Horn filled with ships and boats, horizon lined with domes and minarets, glimmering the smooth surface with gold and morning sunlight from the Eastern world; the aroma of strange spices and sea salt mixed with the coarse smell of diesel that gave the city its exotic smell; motor sounds and whistles, with a muzzin's cries of prayer from a city parapet.

Hauberc has been assigned to observe a suspected courier contact in the indoor section of the old pier terminal of a ferry excursion to the Bosporus and Black Sea. Pursuing a lead intercepted yesterday in a short-wave transmission, decoded by his British contact, Blackwell Hughes, a higher ranking operative, evidently between Turkish and Bulgarian agents, Hauberc awaits his arrival, readying to take up his position, yet squeamish at being alone here. Was he alone at this critical contact point, or only informed as being alone -- not to know who were the others in position here?

This narrow strait between Europe and all of Asia could be the bridge, the transfer point, of data on microfiche which could alter the balance of power, the very proliferation of advanced nuclear weapons in the world.

Here, the cavernous inside of the pier is crowded with tourists and travelers of different nationalities, Eastern and Western, all standing in roped-off queues which fill the rear section of the room...

Hauberc notices that the berth for the ferry itself is a U-shaped dock, similar to the terminus of a railroad track, in the outer covered section of the pier, from which the ferry, yet to arrive, can be boarded from gang-ways on two sides. Presently, waves from the approaching ferry break up the peaceful reflections in the water and lap against its inner sides of the dock as in anticipation of the ripples of altered history.

Even with the crowds, he is fortunately standing in a position in the line from which he has an unobstructed view of the dock and the tiny streaks of gold and brown and silver ripples of water which begin to hypnotize the fear in him. He watches as the ferry-boat comes closer to make its landing approach, and as it slides smoothly into its berth.

As the people in the lines impatiently begin to move by the ticket-takers and out onto the dock platform, he walks along with them as masses of people are disembarking and moving onboard, while he watches for the precise moment of a contact at a spot at the corner of the cabin on the deck of the ferry. Across the dock, he thinks that he sees Hughes finally arriving.

Here he is approached by three men, two of whom are in Turkish Police uniforms, who roughly order him to come along with them, taking him onboard and quickly shuffling him toward a companionway, as the ferry is beginning to leave the pier and move out into the sunny harbor. Glancing back, he is unable to glimpse Hughes again on the dock as he is taken along a narrow companionway to a tiny cabin. Not stopping to tell him why he has

been seized, they shove him into the cabin, only leaving him grateful to not have been struck.

Climbing up from the floor, he finds the door to be locked. Sometime later, another door to the right is unlocked from the other side, and slightly opened... Waiting several minutes, the door still left ajar, he cautiously opens it, where he finds the narrow galley.

The galley hand, walking back and forth between the counters, is preparing various dishes, but as Haubec comes through the door the galley hand over at him and says something casually in Turkish, which he is unable to follow. Hauberc continues to move around the end of the counter, making a gesture of greeting to the galley hand, slowly moving toward the door to the companionway. But the fellow looks up, pointing a small pistol and gesturing Hauberc to move away from the door and just sit there so he can be watched out of one eye. Eventually, with the galley hand looking engrossed in his work, Hauberc edges closer to the companionway and playfully pokes his head into the passage, but then turns back only to find himself looking down the muzzle of the gun again, so he sits himself up on the counter across from the galley hand, wondering what will happen next ...

The constant sideward roll of the boat, and Hauberc's uncertainty, gradually churn his stomach, and he can only console himself that his partner Hughes is aware of his capture and might negotiate a release...

Fifteen hours later, after making steadily eastward with no sight of land from the cabin porthole, Hauberc finally senses that the ferry is slowing into a docking approach.

He is by now completely mentally exhausted with the fearful prospect of his capture, his thoughts having raced into the state of blankness---

Guards come at last to lead him out onto deck, where four other male captives are also being brought out. They are all quickly shackled together at the ankles, as the ferry thumps into the sides of another U-shaped dock to rest, surprisingly back at Istanbul. After the passengers disembark, they are marshaled to move through the gate, awkwardly tripping over their chains as they go.

But now he startlingly realizes that the pier is an exact mirror-opposite of the dock from which they had embarked; and across the pier, through the crowd, he sees his partner Hughes casually walking to a waiting car and being driven off---

(Hope has been removed, and today Hauberc cannot remember his grueling interrogation, but only the name of someone in history named Xerxes, and a long walk inland from the Crimean shores into a Ukraine landscape -- thinking: "Well, here I am as in the poem" : with Tennyson's phrase echoing in his memory -- "Cannons to the right of us/ Cannons to the left," as he is led eastward over snowy roads, a helicopter gunship circling high overhead in the blue to his right, and another to his left...)

"Cannons to the right of us... Cannons to the left of us... We marched down into the Valley of Death..."

prolepsis 10 -- <u>*The Bridge to the Chasm 1944*</u>

Through woods of grass-blade shadows, Hauberc's memory is reeled back from more than twenty suns ago -- even before his own twenty suns now?

-- Deep bush and trees, climbing forest trails, this was somehow the mountain spine of Italy.

I have to bury this map in my hand as soon as I memorize where I am. The Apennines. Walking alone, but not aimless, I had already ditched my parachute and buried it, away from where I had touched the ground. I tucked the small Barretta back into the ankle of my right boot between two layers of socks. Under my arm, a small canvas satchel carried the materials I will need.

From this view on this mountain trail, I can see over the distant hillsides of Umbria, quaint villages with pink stucco buildings, and the church steeple in the early morning angle of sunlight from the east.

I'll have to climb through this rough terrain to get to the other side of a small ravine -- though I was unlucky enough to twist my left ankle badly when I hit the ground, not the proper landing I was trained for. So I now have to worry about getting back to my unit alive, without the fucking Germans seeing me!

General Simone, Grandma's nephew, had hand-picked me for this mission, since I spoke all the dialects, north and south. like a real paisan, with Pop from Sicily, Moma from Ferrara. "Uncle Simone" and Pop had enlisted together in the Italian Engineer Corps back in '14. Then, before I was even born, my little sister Hope, only 4, and Grandma died when the Austrians were shelling Ferrara in '17. Knocking out this bridge would prove my competence and being worthy of Simone recruiting me for Strategic Services.

Mussolini was loosing ground since we invaded the Boot, and he'd soon be defeated, and then just the Nazis left. But I've got to remember to think only in Italian, "Eh, Giani! pensa soltanto in italiano!!"

Still, if I could get to the other side of the valley, walking where I would probably come close to peasant houses I'd be safer -- I hadn't been in this province alone before and so I've got to watch out, not mistake anyone else to be my contact, Fascisti instead of partisan. I hoped no lookouts saw my chute come down, black silk in the black sky?

I would normally be thinking in Italian, except being scared. I knew already what would happen if I forgot to speak Italian right away, if I could stop thinking in English. They might rattle off an English phrase to trip you up. --- Even accidentally holding your knife and fork the American way in a cantina would land you in a torture chamber and being stood up in front of a wall.

All I can think of about now was just meeting up with my comrades to get back to the US lines to the south tonight -- a long walk already but much longer with my aching ankle. They would be specifically looking for me in two hours. Still was no sign of my contact.

Two peasants were walking further along the path where I trod -- stocky tall men with dark hair and handlebar moustaches. Both carried beat-up looking Springfield rifles slung over their shoulders, inconclusive of who might have issued them, maybe leftovers from the Great War, so I decided to just watch them until they moved beyond my area, but not to completely lose sight of them.

The two stopped and sat on some large rocks near where I hid, their voices just within earshot, talking about the new Social Republic, and the news that Il Duce had just flown over to the Germans, but the sound of their words drifted partly to the other direction -- and I still couldn't make out their conversation clearly enough to be sure of their loyalties -- I would just sit quietly until they decided to continue along in the early morning light.

Finally, after more than a quarter of an hour, I was able to make my way deeper and deeper into the woods, careful not to break branches where I moved, now beginning to try to locate my

objective.-- The chart I had committed to memory seemed slightly different from the actual lay of the land itself...

But when I discovered my destination some time later, and looked at my small timepiece, I realized how much later I was now because it was necessary to stop to avoid these two peasants.--

The bridge over a gorge in the mountainside was wide enough and apparently strong enough to allow Panzer tanks and high half-tracks to pass over. Another road leading to Rome.

By the time I had installed the explosives under the second and third bridge supports I realized that the sun was higher in the sky than I hope it would be by now. The timepiece said 0810 hours --

I was just able to get the detonator wire stretched to a safe distance away when I began to hear the sounds of a mechanized unit approaching. They were ten minutes early! Shit!
Fucking stupid goose-steppers. Shit!

They were now already coming out onto the bridge -- This is not what I wanted to happen! -- I could have just done the damned bridge and gotten the fuck out of here, with no danger to myself or having to kill anyone. -- But Simone's orders were precise. -- And *I* was much more likely to get home than *they* were now.

Nazi infantry men were already at the middle of the crossing, two tanks rumbling up in line behind them, then a half-track already off the terra firma – They're smart enough to break their march-step.

Why did they have to be so damned early ? What could I do now? This could only mean certain death to all these men and disaster to their wives waiting for them back home, as Phyllis waited

46

for me. I would be damned for this by God...just for touching the ends of these two wires to the poles of this little battery --

But fuck Hitler and his death camps! I knew the rumors were true after Simone showed me the secret aerial recon photos: trains of cattlecars and rail tracks leading to "resettlement camps" they called them, to which all the Jews of Europe were being brought, though the number of barracks stayed the same... Just a river of people being brought in every day, and no one gets out, and the camp doesn't grow in size ...? But why hadn't our flyers bombed those train tracks ?

But, Oh, God, how can I get out of this? The rumbling of the engines vibrated the supports of the bridge, but not enough for them to give way by themselves.--

I had to shut my eyes tighter and tighter, wondering if I could do it with my eyes closed. Maybe not, as I felt the hot spark snap between my fingers. I will pray for you men about to pay the highest price -- Mother Maria, Forgive me my Soul! The dark velvet inside his eyes suddenly flared to deafening white-orange -- a horrendous deafening blast of plastique and the thundering sounds of men and heavy vehicles falling forward into the chasm: soldiers, jangling utensils, helmets, rifles discharging, and terrified cries.--

prolepsis 11

Just a few hours later, many young people have gathered and are crowding into the garage behind Hauberc's parents' house, attempting to hide from the menacing war and the outside air -- He is huddling everyone in, squeezing himself inside among them, so that he can roll down the overhead door, look out through its small panel windows. Last year, Fred Pageant and Hauberc had made the garage into a space-ship ushering their younger friends into lines of seats, and blasted-off, out of the solar system. Now they could do it again, right now, and escape the fallout clouds.

But now Fred, Hauberc's friend since kindergarten, appears again outside the side window, trying to get his attention before the rocket is sealed up to go. He looks now more like Hauberc remembered him from before, still the same refined looks but slightly buggy eyes, especially at this moment when Fred surely has something to say. Hauberc cannot understand from where Fred has arrived, although the same applies to all the others crowding into the garage space.

He is smiling and starting to laugh when Hauberc pulls open the window:

"I'm glad you've gotten your den window fixed by now," he says, referring to an episode when they were eleven, playing catch in the yard faster and faster until -- crash.

"Were you going to leave without me ?!" Fred demands to know. "Climb out into the alley, I want to tell you something I just saw."

Hauberc climbs out of the window, nearly spilling himself head-over-heels onto the hard ground, into the alley between the four garages back to back. The armed lookout still on the other roof glances down, rolling his eyes.

"OK, what?"

"There's something strange happening down at the pond," Fred tells him, "Hundreds of people are walking around."

"Yeah, I don't know where any of these kids here came from either." "Come on and take a look."

They climb over the barricade, cutting through into the drive-way of a rear neighbor's house and out to the street on the opposite side of the block -- From here they can see down to the end of the

street of houses and down over the landscape and the water of the wide pond.

When they reach the top of the stone steps down into the park, they can see that there are hundreds of people milling about, some picnicking in the field to the right which is split by the brook that feeds the pond. They descend the steps in slow motion, and walk along the people rambling by the sidewalk edges of the water, surprised by this sudden relaxed-looking re-population. On the opposite side, one child drags a red wagon behind him, while a young girl pulls the line of a toy sailboat making waves along the bank. At the far side by the inlet of the brook, two boys in a blue polyetheline play boat poke around the edges of a sandbar in the harsh sunlight. Hauberc remembers that he has seen old colonial-period maps which show this land as virtually unchanged, with a narrow falls of rocks at its lower end, built up by the W.P.A. into a brick spillway topped with a small bridge path. Now Frederick and Hauberc walk wordlessly around the bend of the high stone wall, coming to the lower neck where the water falls into the lower park. Passing by the stone steps down, they cross the little bridge and keep to the ridge where it makes a wide circle behind the lower park, overlooking its old walled-in swimming area of the widened stream which follows a crescent shape to even lower waterfalls.

Another walled brook leads to a culvert and across a road into a lower open park field, and past the old rouge factory. The water in the brook still leaches with yellow and red dyes flushed from rusty pipes. The next street which is called Long Brook Avenue runs between the crests of two hills to the right and left, the stream

crossed by a decrepit wooden bridge, though Hauberc distinctly remembers another culvert here.

Going further ahead through a swampy area, they follow over a hillock path where Frederick decides to turn around to him and say: "Let's pretend that we're in Stratford like it was a hundred years ago, OK?" Pushing through branches, holding them away from his face for Hauberc to catch up, he walks straight along the path.

They presently come out to a pasture where a cow-path crosses east-west, where Hauberc realizes that Barnum Avenue should run down to Ferry Boulevard, to the east towards the river, flanked by the vast GRAND-WAY department store, wide parking lots, and a building tile manufacturing plant further down. But now Hauberc feels lost, as he can only see a few old houses, and a thick grove of elm trees over the crest of the hill.

Frederick is already heading onto the rocky knoll across the cow-path, above the brook, and back into the old Union Cemetery, behind the Fire Department and Masons' Lodge building on Main Street. Up through the field of scattered headstones, Hauberc finally catches up to where Fred is standing looking at one of the flag-decorated new gravesites.

"See?" He points out one stone which reads the name of an army corporal and the dates 1847 - June 3, 1864, 17 years old ?! -- with the epitaph newly chiseled:

"Dear Mama, I'll pin this letter to my fold,
My Comrades all have Fallen,
This *Cold Harbor* is so cold,

I hear my Lord a' callin'..."

Fred leads Hauberc further southwest across the field in the direction of the buildings of the town center, hidden behind a tall thicket of sumac across the railroad tracks...

The sky, once partly sunny, has become completely shaded with heavy clouds moving in, shading the daylight. By another brook that joins Long Brook, they finally come up to Main Street, unpaved, in the town center, but find only a few buildings surrounding: a tanner's shop next to an old homestead, then Ufford's General Store, and a darkened tavern and, across the way, the stately white Congregationalist Church.

As they begin southward down Main Street, somewhat confused, along the line of oaks and beeches and large mansions, a sudden commotion of several horses, galloping up the road from behind them, carrying riders in long coated blue uniforms, passing by them and then turning right up ahead at the Green at West Broadway ---

Following behind them, they turn onto the wide green, where they can see the riders tying up their horses outside Benjamin's Tavern situated far at the opposite end, who are already engaged in a subdued conversation with several men standing outside the place.

Unheeded by the activity, Frederick and Hauberc enter the door of the tavern and find seats at the end of a long table, overhearing the semi-discreet talk going on.

They do not have to wonder long what is happening, as two of the soldiers are relating the events of a skirmish from which they

have come in Ridgefield against a large force of British Regulars who were marching back toward their landing point at Compo Beach by Norwalk Town after burning down the Continental Army supply stores at Danbury --

"Captain Coe's been captured by the bloody Red Coats -- we bear sorry news, men," --they talk out of breath... "General Wooster's been shot bad ---"

"No, by Jesus!" the innkeeper gasps. "How...What happened?"

"We split forces in Bethel when you men went with Silliman and Arnold against their main flank; we were with Wooster closing in on a splinter column left behind. He took a shot through the stomach and went down from his horse -- Looked like too much blood lost -- He'll not make it." The speaker slumps into a seat.

The others begin to speculate on what will become of morale at the loss of a rallying leader, and the loss to strategic planning.

But the innkeeper, who had been noticing the boys' curiosity since they arrived, finally comes over to where they sit. "You two young masters look strangers to this town -- Where do you hail from? And what brings you to Stratford?"

The question takes them off their guard. "I'm Inspection Committee Officer," the man goes on. "and I'll have a look at your papers..."

Frederick and Hauberc look at each other blankly. "We live up at the Green," he blurts.

"You are talking about the green above the ox pasture? At whose house there are you staying??"

"Paradise Green," Hauberc attempts to mend.

The Inspector turns to call the others, "Men! I think we have here those two Tory spies they saw in Danbury two weeks ago! They fit the descriptions."

"Don't let them escape us!" shouts the commander summoning the soldiers over to them.

"Wait a minute," chimes Fred. "Were you talking about Benedict Arnold? -- We can give you important information!"

"It's too soon, Fred..."

"He calls him Frederick! He may be a Hessian!"

"You two will please move from that seat," orders the innkeeper. "Search them for weapons..." They are immediately questioned and at first accused of stupidity for their uninformed answers, then of diabolic deception regarding their claims that they have come from the twentieth century, and next of witchcraft over the dated coins the boys produce from their pockets.
On into the men's questions, the Inspection Officer soon intervenes lest the other inquisitors reveal secret information.

Frederick and Hauberc are taken from the inn and told that they will be brought to regimental headquarters at New Haven, some twelve miles east, a four hour walk. They will be interrogated and charged with espionage.

They are walked along next to the men's horses through the parade ground they call Broad Street, across Main Street, and down New Lane, lined with large homes, by the cemetery to Elm Street with the same salt-box house Hauberc has always known in that lot. The questions Fred and Hauberc ask these Minute Men at first cause

them to accuse the boys, with more conviction, that they are the spies they suspect them to be, as if the boys were so confident of rescue or escape that they would seek to ferret more intelligence.

Heading east, the colonial revolutionaries bring Fred and Hauberc across the Tanner's Brook bridge and up the long Ferry Bridge Road, toward the landing, where they will be brought across the Housatonic River to go on the rest of the way through the Milford Colony on the Boston Post-Road to get up to New Haven. Walking up the carriage trail that traverses a wide heath covered with birds and sunshine, Hauberc begins to feel almost hypnotized with their predicament. But Fred becomes more lucid and begins to tell their captors, as they walk, that one day this would be the path of a turnpike highway with six lanes and no stops from Maine to Florida for motorized "horseless carriages" and also on this site, a vast factory called Raybestos which will make asbestos-lined brakes for these "motor-cars."

"The Redcoats and the Tories *will* run away to Florida now that the king owns it, when we take our independence! They'll *need* a *turnpike!*"

"Yes, and you'll need good spark-proof brakes for a carriage powered by a machine... hah, hah. Will that be enough to stop it?"

"How can you have a factory in the middle of a field where there is no stream for the water mill?"

"It runs on steam and electricity. Its the same thing that Ben Franklin discovered when his kite was struck by lightning." explains Frederick.

"And where will you get all this asbestos stone?"

"Oh, I don't know...South Africa, I think..."

"Queen Victoria will have a colony there after a war with the Dutch settlers."

"Queen who?"

"Over there is the baseball field where we used to go to watch the Brakettes practice, the Raybestos Women's baseball team from the factory. Its like cricket --" Hauberc adds.

"You mean 'wicket'?"

"They play a game called 'cricket' in New York City and in London, too! You know that well enough, Tory!"

"The mill owners will *make* women play field games in public?!"

"No, its for fun, not wagering."

"You two boys would go to a Bedlam house, if we weren't going to shoot you first!"

"--Will these mill owners control our independent nation?," the other asks, ponderously.

"Hauberc, you Zarf, we had better shut up..." warns Frederick.

"Cease these lies!" shouts the Inspection Officer in their faces, lest the boys steal the sympathies of his men. "Hold your tongues and your absurd tales!"

Now they all go along in silence, crossing the wide, scrub field. The same path on which they walked would shortly bring them to the crest of a small rise and down to the bank of the Housatonic River. Would there be a bridge there now? Hauberc remembered going out onto the span which would be called The Washington

Bridge, far smaller than the Manhattan version of the fuller name, remembered walking out halfway across, looking down at the surface of the water below, and finding the iron gate unlocked so that Hauberc could climb the narrow stairway down one of the concrete support structures to the waters edge, hoping not to be seen, but spotted by construction workers, so that Hauberc had to run back to the top of the steps, and furtively retrace his steps back to the Stratford side.

But now wondering what will become of Frederick and Hauberc when they are interrogated at Regimental Headquarters in New Haven, he suddenly, finally realizes that he is walking by himself, somehow, as though he always had been, that there were no others, but that he has been led here by ghosts.

Coming over the rise, he could see no sign of Moses Wheeler's Ferry Landing as he knew should be here, that should have been here since the beginning of the Stratford Settlement. In fact, the only sign of habitation are some campfires visible deep in the woods on the Milford side of the river.

Now, fearfully, he recalls the game that Frederick had concocted to imagine the town in the past, and the game Fred has disappeared in the middle of, just as he has always been prone to do when they played in the woods, not to be late for supper at home...

A gnawing feeling of aloneness descends over him, as he tries to figure ways of crossing the wide but calm river. Instead he chooses going west back over the trails behind him, consciously repeating the same journey as when he earlier return home to an abandoned 20th Century town.

But mostly there were no trails leading anywhere, much less where he wanted to go. Now he could cut through the scrub-brush heath, making his way across a dry chalk bed, and eventually through other maple groves, coming along a puddly open meadow at the place which he knew would one day become football and baseball playing fields of Long Brook Park.

One narrow path led slightly north up along the edge of the hill into the area the innkeeper had called the upper ox pasture, bringing in view the same long brook which Frederick and he had followed downstream. To the right, he could see the same undeveloped woods as would still be at the end of the street of his parents' house, where he played and dug holes and tunnels as a boy.

The little path led up the slope, sparsely lined with tall oak and elm trees, bringing him closer to some thatched, rounded-top huts located further back in a clearing, which he momentarily recognizes to be wigwams, situated almost on the very site of his parents' and neighbor's car garages.

Cautiously approaching, he attempts to hear or see whatever inhabitants there might be about: At a spring closeby, a handsome, middle-aged Native American woman was washing some clothes over rocks where a tiny brook was formed, passing to the west

towards the pond he knew would be a quarter-mile away. At a small campfire some small game is being cooked on a spit with its sour smoke drifting over him.

But then behind him there is a sudden crashing through the underbrush to his right, and Hauberc turns to see a young Indian man running at him. He grabs at Hauberc, but is moving so fast that he only succeeds in knocking him over to the ground. The woman, now alarmed, starts to run to her wigwam, but her flight is interrupted by the sharp report of musket fire in the air--

As she topples down in pain, Hauberc realizes that the rumbling noise he'd heard as the young Indian was coming at him, was the gallop of approaching horses. An arrow flashes through the air striking one of the five white riders in the collar.

Another rider throws a torch upon the wigwam, sending flames immediately billowing up and around its sides: The screams of young children emit from inside it. Hauberc runs through the open to the wigwam.

"That's one of them there, Capt'n Mason---" points one of the riders at Hauberc.

In the split-second, Hauberc sees the musket swinging around in his direction, hears the quick report of the hammer, and the echo of gunpowder off into the sky -- sees the impact of the musket ball and the red mess in the center of his chest.

Fallout

prolepsis 12

Heavy gray coldness outside, he came back to consciousness, still lying prone between the same two garages which looked like the edge of the backyard of his folks' house. Waking alone here, that same isolation slowly came back to him, again -- that in the cities and towns no one was left behind, that the milky gray skies were still warm with the sparkling spores of the sprouted "mushrooms," the spores which sprinkled poison silver-dust over the map.

In the summer, the warm garden of honeysuckle, which overgrew the page wire fence bordering narrow walkways between the garage walls, had filled the air. At the base of the back door steps, a copse of green leaves and purple blooms of lilac made a little shade grove. In the small patch of earth between the garages his grandfather kept his garden of eggplant, green peppers, tomato plants, with one fig tree; which his grandfather would wrap and tie up to keep alive through the snowy winter.

In their neighbor's garage next door, a policeman lived, old Rudy had told him as a small boy, so he knew not to go too close -- but he sometimes would stare into the window. They didn't have a car to keep in there, so there was room for a workbench and tools hanging on the bare wood walls, but it didn't look too comfortable for anyone to live in there.

The other neighbor's house was the Kaeser's, a small house with nice pines shading the front steps and low-hanging fir trees enclosing the back-side door. Conrad, old Mr. Kaeser, a self-styled artist now probably in his eighties, had for many years painted patriotic red, white, and blue rings around the telephone pole which held a small U.S. Mail-box, then all the other poles for blocks around; then the same color-scheme on the stone seats at the base of the shady hills surrounding the gravel-bottom pool down in Longbrook Park.

Mr. Kaeser had several times invited Hauberc and his sister down into the Kaeser basement where he had painted lovely murals

of Walt Disney characters on the walls, Snow White and the Seven Dwarfs, Pinocchio, and others. He showed them a huge wall-paper sample book in which he had glued-over the wide pages with newspaper "fillers" – short-paragraph stories about all kinds of topics.

Now, a rumble that shook the air above like heavy thunder was really a sonic boom from somewhere in the blue above the cotton landscape (through empathic eyes). Down here, huddled on the ground, there were clammy beads of sweat in his armpits and on his forehead, and that same sour metallic taste in his mouth.

Back as a small child, he was with his mother and little sister Juno, after spending the afternoon shopping at Howland's and Levitt's department stores and especially at the big H.L. Green 5 & 10 Cent Store in downtown Bridgeport.

It was a sunny afternoon on spring vacation, and now they were parked on a side-street around the corner from the entrance of the Columbia Records factory on Barnum Avenue where his father works, waiting for his Dad to come out at 3:30.

He was happy today because he has finally gotten something that he had wanted for a long time -- a beautiful set of tin soldiers with uniforms which look like the armies of different countries of World War I: British grenadiers, U.S. "Doughboys", and Germans with spiked helmets. Each one pointed a rifle or a pistol, standing, crouched, or prone on the ground.

While waiting for his Dad to come out of work, his Mom and Juno are up in the front seat talking about girl-stuff, so he starts setting up his army-men, arranging them out on the backseat facing each other from across the upholstery, rumpling his brown jacket out across the seat to make hills and valleys and trenches for them to hide in ambush for each other. Since it's already warm outside, he also opens the door and moves the battle to the cliff of the edge of the seat and sets up the Germans below on the little flat metal ledge beneath where the backseat door closes, and the battle is poised to

begin. There they are crossing the field, with the allies above ready to stop them from advancing.

Suddenly, the car shakes as his Dad opens the front door and jumps into the front seat hugging and kissing Mom and Juno. But when Dad shuts his door the car bounces again, and all the soldiers on the metal ledge already unsteady now start falling over. It's too late for him to catch them as they all fall out of the car and tumble to the ground.

"Oh, No!" he yells, because he hadn't seen that the car was parked over a sewer grate and the soldiers keep falling, already slipping down through the grate, and he is helpless to catch them. As the soldiers slowly drop and tumble down and down into the tiny bottomless pool deep under the street, for one instant he can first see his own face reflected from above before the water swallows them up forever and his reflected image breaks into small circles ...

prolepsis 14

Alone on the beach, absolutely Nothing around was familiar, though he knew somehow he had stood here before....He had climbed aboard the only bus he saw, and the route had strangely gone down a wide avenue between two, mile-long windowless tall super-structures. No one else was riding, and now the driver directed him to get off to make his connection, dropping him at a stop before an expansive network of intersecting and branching ribbons.

On a wide sign post was stapled a flier with musical notes in the margin, reading simply:

MILIEU NO. 8

A Program of SCARLATTI, HANDEL and CHOPIN

4 PM Today Only, The Pier.

But already it seemed to be getting late, stars appeared in the dimming sky over the south eastern horizon which looked like two spinning solar-systems (though golden light of twilight still reflected on tall buildings in the distance) ... Now he saw that he actually stood on a two-dimensional ribbon-plane which had coiled in below the stationary stars; and extended over the horizon to the east. And hovering far over that was a deep cylindrical shaft with a glowing orange interior far inside that -- an edgeless, borderless parabola.

Suddenly a jet plane flying out of the shaft barely missed him, skimming the ribbon's edge at about mach-2, with a screaming sonic Doppler wave that deafened him and knocked him to the pavement, then plunging him again into deafened silence.

Getting to his feet, he could see two other buses moving along here and there off in the distance, but none coming down this ribbon---

"---How do I get out of here?" he asked a man standing at the intersection of sunlit plastic paths --

But impatiently waved away by the man, he trudged on, the sun low in the black sky now beginning to glare with uncomfortable warmth / until he was back again at the Lordship Seawall, where the waves normally rolled ashore...

An old-fashioned style wooden pier had been built while he had been away, and many people were walking inside. A fellow he vaguely remembered recognized him as he imperviously watched the scene, asking "Going to the concert ??" He nodded and he followed along chatting, embarrassed to himself that he couldn't yet remember the fellow's name ...

The auditorium on the pier looked big enough for a recital, as he was handed a program: a concert hall with a great curved window behind the stage with a sweeping view of Long Island Sound, the west and east shorelines, and southward out to sea...

Though before them stood a beautiful grand piano, music began playing from another one unseen, and the program persisted for some

time in this way, until a group of children in the front row began to grow restless with the mystery:

"Let's try this side door that goes farther out on the pier!"/ "It must lead to another hall!"/ "No! It's the end of the pier!"

But the door was stuck and would not pry open.

All was stillness, as the first piano piece concluded, except for the perpetual rollers that washed themselves ashore/ sweeping along the jetty until dying at the beach gray sea reflecting gray sky (always gray nowadays) but so s t i l l

No One was really playing the piano, but without regard it persisted. The door still stuck tight, concealing

the piano player's lack of identity

waves rolling, outside

By the first week of November of his freshman year, his life at this uninspiring college had finally begun to improve: As soon as he received his first acceptance letter from the State Teachers College in New Haven, his father considered it a done deal, with congratulations... Hauberc liked New Haven: the well-stocked book stores, and the Beat coffeehouse called "La Gallette" that still remained a scene of poets and artists relaxing and talking about their writings and paintings. These had drawn him there even before he got his drivers license, the very day before JFK was shot, but he would have to live at home in Stratford and commute every morning to school. Now he had decided to take the initiative in several of his classes, by applying his own thinking and advanced reading in Psychology and Sociology, his chosen major and minor subjects, and ask serious questions in class, rather than just accept these instructors' conventional renderings by the book. Moreover, he had been an intellectual leader in high school, as an outspoken anti-war advocate which attracted others to his Humanist and individualist values, and he was not so willing to confine his thinking to tacitly accept the status quo and the litany of reasons being given to escalate the war against the poor rice-farmer Marxists in Vietnam. At 13, he had been watching TV when President Eisenhower gave his farewell address, and he wondered just what the old World War II General, Ike, had meant when he said the nation needed to beware of the "military-industrial complex." What the heck was *that* ?

Now in his freshman year, he had the feeling of being watched.

-- Someone had followed him several times, he was certain, but after several days he finally realized it was a curious-looking pert young woman with long blonde hair and a kittenish face that he had passed alone and remote through the corridor of the main class building. He was sure she had even turned and walked after him, concealed in the throng of other students -- And now, as he walked out into the walkway path with that same feeling again, he suddenly turned around and glanced at the window of the exit doorway he had just passed through -- and there was just her petite face, framed by the glass of the little window, her eyes caught for a fleeting second ---

The following noon-time, he took his place in the hallway line going into the cafeteria room of the Student Union hall, leaning against the wall and looking down into a paperback book of stories by Franz Kafka, when suddenly another pretty young woman student with long black hair appeared next to him in line and smiled subtly, suddenly chatting with a smile. "Hi, I'm Marina. What are you reading?" He lifted up the book cover to show her. "Are you a Lit Student?" she asked curiously.

"Psychology and Sociology -- but I'm thinking of changing my minor to Literature..."

"Really ? -- Psych and Sosh -- that's an unusual combination -- Um... you should meet my friend Margo, we're sophomores -- that's her same major and minor too --"

Two days later at noon-time, he was there again waiting in line for lunch, and there now appeared this same brunette, this time with another friend, the same petite face he was certain he had glanced in the window frame...

But later that afternoon he again passed through the corridor near the Administration Office, when this time a young man in a suit accosted him, "Have you had your hair cut recently? Our dress code doesn't approve of your boots or black jeans..."

Hauberc looks up, amazed at the man, who introduces himself, "I'm John Gunnar, Assistant Dean of Students... What's your name, young man?" The pronoun phrase seemed strange coming from this fellow, who looked only about 19, sandy-haired clean-cut.

"No one ever criticized me in high-school for my taste in clothes.." Hauberc replied.

"You're in college now, young man, and you'd better dress for success! I want to see you next week in some conventional attire and a haircut. Come to see me Thursday at 2 PM, Office 222."

By Friday he was so preoccupied about his late-night dates with Margo, who turned out to be the same girl with the kitten face, that his one encounter with this "juvenile authority" seemed really remote. Having to live at home and drive the second family car to college every day, his father didn't seem to be aware that he would get home from Margo's off-campus apartment around 4 AM several nights a week, so that the car would be home when his parents got up at 6 AM.

His Pysch class was an auditorium full of kids with a panel of team-teachers on the stage. -- No one from the audience asked an interesting question. After a month of this, he had approached the

most knowledgeable-looking of the "team," his office actually an over-cluttered desk behind the curtain of the auditorium stage. -- "Professor, will we read anything of Freud's this semester?"

"We're not so devoted to Freud in the first-year study, we want to give a wider background in clinical principles..."

"Well, what about Georg Groddeck's clinical theories -- he was a correspondent of Freud who did mostly clinical work, and came up with a theory in *The Book of the It*", about the independent actions of the Subconscious in the individual ?" The prof gave a blank look.

"The term Freud used was 'Id,' Freud even gave Groddeck credit for inventing it," Hauberc rejoined, "in *The Ego and the Id.*" Feeling now out on a limb, he tried to balance this statement, explaining with a smile, "When I was 12, I loved "Adventures in Paradise" on TV and was reading *Two Years Before the Mast* and *Moby Dick* and I wanted to go to Tahiti -- I was looking for books about the South Seas and I found a book called *Totem and Taboo* -- and was pretty surprised!"

Dull thud, "Oh."

"When I read *The Ego and the Id*, it reminded me of Moby Dick submerged under the waves, tormenting Ahab, the father figure...

"Sandor Ferenczi's also worked with Freud. Speaking of the sea, I'm now reading his *Thalassa, a Theory of Genitality.*"

This drew a rebuke: "*What* are you reading *that* for ?"

The next morning, in "Sosh" class, the topic got around to the "nuclear family" structure, and mentioned how young people were

moving away from their families to start their own lives working for big companies being paid enough to support themselves. Sitting in the back of the room, Hauberc had raised his hand and asked, "*The Organization Man* by William Whyte, talks about that, but what about young people who move away from home in order to find their own individuality...?" The instructor, a typical-looking woman in her mid-thirties with frosted blonde hair, simply paused for twenty seconds, looking down at her papers, then went on to the next question from a conventional-looking female student in the front of the class. By this point in the semester, early November, the class favorites were already chosen...

Now he felt that he had gotten himself in "solid" with his teachers, ironically. It was past 1 PM, and Hauberc sat alone at a dining table in the Student Union wondering if he had already missed his friends for lunch, when suddenly another face, the young Dean of Students was looming over him as he tried to chew his food. By now he had begun to hear crazy stories from other students, even those with only short hair needing a trim over their ears, that they too had been stopped in the corridor. "You missed your appointment with me yesterday, Mr. Hauberc.. Please show me your Student ID card." Hauberc took out his card from his wallet and handed it to Gunnar.

"OK, thank you," Gunnar said, putting the card in his shirt pocket. "Be in my office next Tuesday, November 9th at 2 o'clock with your hair cut according to school regulations, and you'll get you ID back, or else you're automatically suspended."

Hauberc in the hasty encounter neglected to mention that he had a Math class at 2:15, Tuesday. But on Tuesday, before class as he lingered outside his math room, a messenger walked up to those standing by the door. "Who's John Hauberc?" But no one else answered, and neither did he..

Inside the class, fifteen minutes later, the messenger this time entered the room and spoke to his instructor. She looked up straight at him: "Mr. Hauberc, you're wanted in the Dean Gunnar's office right away.."

When he walked into the office, Dean Gunnar spoke succinctly, "You're already under suspension as of 2 PM. I want you to leave campus until you make another appointment to see me personally under the conditions we discussed. That's all, Mr. Hauberc!"

Hauberc walked out of the office, both terrified and almost laughing. He went back to his car and sat in the parking lot and studied and pondered until 4 PM, then drove to his part-time job at Dow Corning in the Trumbull industrial park, arriving at the manufacturing plant at 5:15 where he worked four times a week as a night watchman.

His father was also on the staff here as a production planner, and he greeted Hauberc with his usual mix of off-hand pleasantry and inward scowl.

Hauberc was suddenly perplexed though, wondering how he could tell his father what happened today at school. "No," he thought to himself, "I'd better wait and figure this out first.."

Almost 5:30, Hauberc walked down the corridor, to the door to say goodbye to his father and the other dozen or so office and plant employees done for the day. "See you home..." Dad says nonchalantly as he exits the door, and Hauberc follows, thinking "Well, I didn't tell him.." By the time he reaches the door and peeps out the little window, his father is already getting into his car, parked right outside the door, and is starting the motor, gesturing a quick wave with no smile.

At this instant, the florescent lights in the hall began to flicker and dim for several moments, then all popped out at once, and the building goes dark, and the parking lot lights off too, in the dimming November early twilight. Hauberc opened the door and shouted to the guys still in the parking lot "Hey, the lights just went out!"

His Dad and several others began to filter back inside to check the fuse boxes, the main circuit-breaker, the outside lines. Eerily, the early dusk seemed to plunge the whole neighborhood into darkness.

One of the guys walks back into the building saying, "Jeez, CBS Radio just said the whole Northeast just went out !!"

The telephone still worked, but with a strange winding sound.. Turning the dials of the secretary's transistor battery radio, they could tune in only one weak signal, the local station in Bridgeport. "We are still on the air with our own auxiliary power...At 5:28, a few moments ago," the tinny voice says on the little transistor radio, "telephone reports are now coming in from all over New York State, New Jersey, Connecticut, Vermont and Massachusetts, that the entire

region has lost electric power. Telephones seem to be working, on a separate circuit." A few minutes later, the second report adds, "The Niagara Falls Generation Plant has caught fire, and all linked power grids in the Northeast have shut down."

It was November 9, 1965.

prolepsis 16

-----> An odd place

to find himself waiting on his first day in Boston.

Waiting, waiting in the sitting room of Dayan's dorm, waiting for her to show up well into the night. It was now 11:30 PM and no sign of her. Five years ago, he had first seen her the first day of 10th grade homeroom in their high school, standing for the Pledge of Allegiance, but she would never accept his invitations to go anywhere together without others along, like Opal.

Dayan had now invited him to come and visit her at school in Boston before his departure overseas, and was to have had a place for him to stay with a friend nearby named John, off-campus.

Now it was the beginning of February, Margo had broken off their romance, and he hadn't been able to get his father to agree to let him transfer to another college. He had decided to let re-registration for the Spring semester pass by and to leave home for as long as he could with the money he made from being a night-watchman.

For the rest of the Fall semester, he had managed to stay out of Assistant Dean Gunnar's sight, after the situation had mushroomed out of control, thanks to Margo's friends on the staff of *The Yale Daily News* having published an interview with him, misquoting him as mocking the president of the State Teachers College as being bald … He had finally gone to Dean Middlebrook, Gunnar's superior, and apologized for the whole episode, saying that he just wanted to get an education, be a serious student, and not cause trouble…. The thoughtful Dean looked at his high-school record and had written him a pass to go back to classes on the agreement of a hair trim.

But still the same pattern of social programming persisted in his main courses, and he was pulling B's when he could tell his reading background was further advanced than the students getting A's who parroted the instructors ideas…. Instead of registering for the next semester, he got his passport and booked passage to split on a Yugoslavian passenger-freighter.

OK, being here, stranded in Boston right now, was a dry-run of pitfalls while traveling alone, and he tried not to connect this situation with other disappointments, and not to be discouraged by Dayan's neglect of his stated feelings, unrequited yet kind yet

twisted. Already the same pattern beginning to repeat: he had waited here fruitlessly five hours for Dayan to meet him, sat in the lobby of the Boston Conservatory administration building, then in the entry waiting room of her dorm.

Now past midnight, the proctor lady asked him to leave. He ventured out into the February night, called the YMCA, no rooms available, a hotel room would spend all the money he had. He went to South Station, and sat in the rail waiting room, and would try to read all night, but around 2:30 am the guard told him the station was closing. Finally walking to find the Y, tripping with his suitcase over icy and snowy city sidewalks: he would have to sit in the lobby like a lost soul. But they sold him a room.

He climbed under clean white sheets, exhausted, passed into a future story: A sunny day in Boston, at first it was tomorrow, he knew Dayan was coming to meet him at her cafeteria.

 Built on a crescent-shaped block, the street called The Fenway overlooked the swampy-edged meadow, the famous baseball field on the other side. Now it was next year in his sleep, Spring after he has already come back from Europe wanting to find her again, still. These buildings seem unchanged since his first visit, but yet this school corridor did not even feel familiar since last evening.

Unknown people
walking by him, just as a stranger

coming late into the semester, he would be a student here too

Then Dayan, pretty and demure piano student, like a stranger from his home town, a stranger from his high

80

school home-room, finally comes in view across the corridor, floating up to him, as simple as though having seen him every day, to say "..hello." (in perfect bathos).

He had envisioned that she would come walking in through the glass door (an ectoplasmic entrance), to embrace and kiss him hello/

-- But walking with her he begins to feel happier, becoming re-accustomed to her reticent, slightly pigeon-toed charming manner, yet he is still apprehensive about starting new classes...

The busy lobby now beginning to clear, the walls come in view as wood paneling.

Across the room walking toward the modern escalator, riding up to the annex of classrooms, he wonders aloud that his classroom must be like the deck of a sailing ship since the musical instrument he will Major in will be the

Capstan (with strings and bow).

81

Back from overseas, he was hard at work there for months already, a factory in the west end of Bridgeport, a job given him as a material handler in the manufacturing production of military ordnance. Cast back into this purgatory, thanks to his Uncle Simone, who would keep him from being shipped off to combat in Vietnam, as long as Hauberc did a few things for him. -- A depressing, grinding factory workplace, but he still felt more sympathy for the others in this industrial dungeon, than his own misery at being given this secret security assignment, as they called it-- so secret they wouldn't even tell him until he had actually arrived. Rather than face a bad discharge now, he could eventually redeem his situation.

Lines of long assembly-line work tables on one side of an open warehouse size room, windows overlooking the stone railroad viaduct where the trains chugged by every hour. Women of all ages were seated women on stools, piecing together tiny electrical parts to be bolted together inside cigarette-pack size olive-drab triggering cases; and, on the other side of the room, from asbestos-sided oven conveyors there emerged a steady stream of plate-sized devices still hot, their component parts were ball-bearing pellets of steel sealed in layers of hot gray Devcon plastic, each encased in an olive-drab curved panel: Anti-Personnel Land Mines!

As each unit comes out of the oven conveyor, it is picked up off the warm steel grating and its plastic casing pulled apart – revealing its layer of ball bearings pressed down with knob-handled bolts and cooked into its Devcon mold. Each unit is handed off to another man

who deftly uses a triangular sided metal blade tool to scrape away all the excess hardened glue while still warm and soft thus producing one more diabolical device ready to be packed for the field with a pouch of explosive powder.

Hauberc knew where these pieces were going once they were packed into cases of twenty-four sections each and shipped off, first to Fort Bragg, North Carolina, then to Vietnam.

prolepsis 18

He reminisced his trip to Boston, more than a year later now, as he waited for Dayan's face to perhaps appear around a corner. The following days with her when they had jaunted through historical houses in Cambridge, philosophizing Pythagoras, singing and harmonizing Beatles' songs, "Eight Days A Week" and "If I Fell," their voices weaving together in perfect counter-point, their eyes breathing all their memories, and their future memories of this moment ---

The first morning he finally caught up with her, after wandering around Boston, she had led him immediately to her first class of the day in a large auditorium, where they couldn't even find two seats together. He had watched her from across the rows, soon realizing that the conceited, affected young man sitting with his clique-ish friends several rows ahead of her, was the same "virtuoso piano student" she had spent the previous evening with, and who would now barely acknowledge her presence...

But another year later, when she came home from school the second week of May, she telephoned at 7 PM and asked him to come and pick her up at the train station. It was a Wednesday, the night before his 20th birthday. When she got into his car, she asked him to stop on the way for a cup of tea and a sandwich. "I haven't called home yet," she softly said as they sat together. "I told my Mom and Dad I was coming home tomorrow." "What are you going to do?" he asked. "Can I stay at your house tonight?"

At 9:30, he went in and asked his parents if Dayan could stay overnight. His Mom looked puzzled but sympathetic, Dayan would have his room, and he the living-room sofa, but as he briefly said good-night to her, she pulled a cotton nightgown from her suitcase. Instead still dressed, before bed-time, they sat together on the living-room floor in front of the stereo listening to two of his new Rock albums that she wanted to hear. Playing a song on *Fresh Cream,* "Dreaming," she told him over the volume, employed atonal harmony, and Pink Floyd's "Interstellar Overdrive," carried out the

constant line of a Baroque continuo.

At 6:30 AM, his parents were up, and he entered his room and sat on the chair next to the head of the bed, watching her softly sleep for a long time before touching her face to wake her, and her amber eyes opened smiling.

On the first Sunday of June, two and a half weeks later, he picked up Opal and Dayan at 1 PM and drove down to the beach at Lordship, the south end of Stratford, facing Long Island Sound. Uncle Simone still kept calling him, telling him to get Opal to tell him the code to reset the Communications circuit which she worked on at the phone company. He couldn't just come out and ask her...?! And now Opal brought along Dayan, to complicate the whole thing.

Opal and Dayan wanted to go to an art opening in Milford this afternoon, but Opal had something good to smoke in the car first, so he drove down toward the beach past Lordship. Sitting three across in the front seat, they passed it back and forth, until they were all blitzed.

Listening to a New York FM Rock station on the radio, he was hoping they would play some Stones, to match the mood he was now in, but now they were playing the entire new Beatles album on the radio, "Sgt. Pepper's Lonely Hearts Club Band," just released on

Friday, and the last song started as he pulled into the long parking lot and parked facing the unusually big waves smashing the sandy shoreline. The sunlight glinted through the waves and flying spray, creating a prismatic rainbow of colors.... Lennon singing: "I read the news today, oh boy......" The song went on and on about 4000 holes in Blackburn Lancashire and the Albert Hall, and Paul riding a double-decker London bus. The music finally rose to a crescendo at the coda, then dropped to sudden silence. He thought it was over, but then it pounded an enormous punctuation at the very end, which came over like an Exclamation Point of History ...

The enormous organ sound slowly diminished, slowly trailing off a long decline to silence

Next to him, Dayan said quiety, almost to herself, "Augmented, sustained, then diminished... it's beautiful."

Stunned all together by this crescendo, they got out of the car and walked down the beach. Dayan walked further down the shoreline, lost in mysterious thoughts. Hauberc climbed on the big rocks of the stone jetty and walked out towards the end of it, staring out to sea, as the large waves splashed over the rocks, sending up a rainbow of colors in the high spray. These could be the Last Waves, one after the other.

The feeling was the foreboding of Time, endless Ending.

Opal came up behind him during this reverie, asking, "Did you get that Punctuation Point? That's John Lennon's message -- it's the End of History!"

At the art and photography opening in Milford, they chatted with artists friends and drank allot of red wine. The art show was in a common room at a Howard Johnson's motel, and when the party wound down, one of his friends had taken a motel room for the day across the lawn. After three more bottles of wine, they were giggling and somehow all lounging back crowded on the two beds. Now Dayan was really next to him, both their heads on one pillow, and he reached out to put his arms around her and held her close to him for the first time since he ever saw her, kissing her face, her soft cheeks, her eyes.

Someone on the other bed started to kiss Opal and she called out "It's a play orgy," quickly sitting up; then everyone got up to go home, it was late.

He awoke before the alarm went off the next morning, a Monday, with the second sensation still under his eyelids from last night, of Dayan softly tracing her finger tips on his face, sitting next to him as he drove down the River Road taking them home. Now the clock-radio clicked on, an early June Monday with the first sunlight coming in the window when he opened his eyes.

But the clock-radio now spoke "It's June 5th. War in the Middle East today: The UPI and Reuters reports that Israel Defense Minister Moshe Dayan is battling neighbors on all sides. Israeli jets are attacking Cairo, and Israeli armored divisions moving into the Sinai Peninsula, against Egyptian tank battalions. Jordan has opened artillery shelling on West Jerusalem."

After a few minutes listening to understand this, he heard the phone ring in the other room, and his father walked in and handed him the receiver on its long wire, "It's your Great-uncle." It was General Simone's voice, "I thought you were supposed to call me last week with the information I needed – last week ?! last night?! All Hell is breaking loose, we're already bumped up to Red Alert with the Ruskies. Our jets are scrambling ! I think you fucked up your job!"

B o o k T w o

The Peripheral Sea

prolepsis 19

Setting their suitcases down on the small stands provided by the hotel for this purpose, they began to unpack. It would be an interesting stay.

Beyond his pastel-green socks and through the balcony French-doors, the city outside was under the stifling blanket of a dead, sunlight-saturated cloud.

The appointment for later this afternoon was for 3:30 pm. He supposed he would be there on time, but he wondered, who gives a damn, a dime?

He would be there.

Walking, later, through the office's outer waiting room, and directly into the inner office, the confused secretary looking up. He felt nothing wrong as he barged into Mr. Stuffington's office and plopped himself down into the luxurious chair facing the desk.

"And who are *you*?" blustered Mr. Stuffington.

"I'm just the janitor...May I borrow your yacht this afternoon?"

"Certainly not."

Anyway, the canal through Longbrook Park, spread over the small suburban valley, was not very wide, but the narrow channel seemed deep enough. The still surface was a glimmering mirror of the black and green hues of the grove of maple and elm trees on the water's edge only a few feet away, and the breeze refreshing.

The wooden hulled sailing yacht had no trouble at all gliding through the narrow waterway, no trouble at all gliding up onto the canal's bank, uprooting the moss...

"Try reverse," his sister Juno suggested, next to him at the helm.

It was a beautiful ship, but too damned long to fit thru this canal.

And difficult to steer going backward.. The choke of the engine and glubub of water under the propeller, then with an autonomous crunching run aground onto submerged jagged rocks. Into forward again, now minus a section of the stern hull.

The ship's ribs were exposed indecently, inflicting him with a sick abdominal feeling of loss-- but it was all right (he looked at his wrist watch), it was just 3:31

-- only one minute late.

The empty popcorn box theatrically skipped five-hundred eleven (511) times across the surface of wide Brewster's Pond, the upper cataract of Longbrook Park.

Finally coming to rest on the surface where it had bumped against the cement-edge wall of the suburbanized pond, on the opposite side from where Hauberc had sent it sailing across. The scaled little white iceberg just sat there on the smooth surface of water -- its gleaming whiteness seeming to attract scrutiny.

The popcorn box littered the pond.

On the distant, opposite bank, an Air Force officer he had earlier seen walking arm-in-arm around the pond with his girlfriend or Mistress, or Something, abruptly rose from the bench where they now sitting, heavily making-out in the sun-light, somehow thinking themselves alone, and yelled "Hey!" across the water, and pointed his Air Force-blue sleeved arm at a sign on the north bank that read "LITTERING $2,000,000 FINE OR LIFE IMPRISONMENT, $1,000,000 REWARD FOR INFORMATION LEADING TO CONVICTION. (Per Edict of Stratford Civil Police Department)."

The wagging finger pointed in the direction of Hauberc's small figure now cowering behind the stone wall abutment of steps leading up from the park to the foot of Glenridge Rood, as the Air Force officer started pacing round the pond towards him.

Young Hauberc somehow knew that this was the pilot of one of the bombers which had loosened its nuclear weapons on humanity.

In response, the furtive little figure lined up his thumb-nails like the sights of a high-powered rifle, wishing to put down the adulterous, war-criminal Air Force officer before he could effect pursuit. Through the rifle-scope he could see the Captain's features, mustache, deep set eyes. The crosshairs lined up down toward his heart, but on his uniform lapel, and he could read the name "Capt. John Hauberc."

Nothing more, he couldn't pull the trigger. The Captain wanted his Cool Million and around the pond he came, and young Hauberc took flight, up the stone steps, and running through the maze of streets behind him, to return to his hiding place in the alley-way.

Aboard a passenger freighter leaving New York for southern Europe, they've set sail hours behind schedule in the late evening. From across Brooklyn Bay, as the ship heavily slides out of its berth, out on deck they can see the island of Manhattan to starboard and its jagged edge of skyscrapers gradually cloaking over with darkened clouds as they move into the wider waters of New York Harbor. They pass beneath the tall Verrazano Narrows Bridge, the string of lights along its suspension cables illuminating the ship with one last civilized fluorescence before it heads southeast out into the vast open water of the Atlantic and pitch blackness---

The cloudy overcast weather was soon blowing up into a huge windy storm and the scatter of spray up over the bow of the ship....

The time is neither past nor future, but late evening in a world progressively alien and hostile to his affection, and he returns out to deck alone to watch their embarkation -- as though it might just as well be an interstellar voyage into outer space with no intention or possibility of return to Earth --

The ship is already into heavy seas, beginning to pitch and roll with unfamiliar apprehension........

A full day goes by, with its weather still in the throes of late winter, while their thoughts languor in anticipation of the warmth of

the Gulf Stream ahead; but the is air chilled in the broken moments of sunshine and icy in the hours of milky, windy overcast. A day of initial contacts with the other passengers and smiling but laconic crew members.

At 4 AM the following night, however, Hauberc is shaken from his still unsettled sleep by the sounds and sensation of the ship slowing and turning as it mysteriously comes to dock in a strange port that does not seem to belong here on their southeast course : a brightly lit modern city on an island not far out in the Atlantic...? -- Not a low-level ring lagoon as might be Bermuda, but a rugged mountainous skyline, some new Atlantis city, providing escape even from the stormy weather.

Brightly lit windows of a line of shops a short distance from the harbor, which is built into the enclosed shelter of the city, attract the passengers to descend the gangway and walk along through the twisting pretty streets until becoming quite lost...

The next morning Hauberc and his few fellow passengers who had ventured forth in the night awaken to find themselves in a dilapidated cabana in sight of the beach on the wind-ward east side of a tiny barren desert island, no shops in sight --- This island is too small to have a ship's port !

High in the clear sky Hauberc sees a four-engine propeller airliner droning from west to the east, as had been the progress of their ship, and he stands out in the middle of a wide asphalt covered field trying to flag it down -- however meeting with little success...

95

prolepsis 22

(Black Night different dock, different ocean of time,
aboard a cargo sailing schooner getting under way,
passing along other busy docks, past a pleasure boat sales lot.
(Theme playing, softly).......ship gliding through the
winding canal, cargo shifting below deck, longshoremen
calling and waving from the jetty.
sitting out on deck (good melody)......captain
by helm...
Black Night ship in rolling dead ink sea,
drab sails set into unfelt wind blowing - - -
view : around before the gently dipping prow.
Phantom heading into Unknown Archipelago

Looking through mind-feel of creaking tightening
cabin wooden ship

Into dead, black; a lantern flickering from one
aft cabin porthole....

prolepsis 23

For a few weeks Hauberc had been inviting Fred Pageant, his
friend since kindergarten, the class comic, to come over to his house
to play after school. Finally, one day Fred said to him, "This after-
noon is the big episode of Rooty Kazooty on TV. I'll come over if
we can watch it -- We've got to see this show ! "

So here they were camped on the floor in front of the little black & white TV screen watching the Rooty Kazooty Show : Fred explains that this episode was exciting because one of the main characters on the show named "Poison Zumac" has decided his name is too scary and is now going to change it to "Poison ZanZaboo"...

 -- Right, thought Hauberc, That will fix it ...

 And just then Juno, Hauberc's little sister comes inside and says "Hi, it's time for the Pinky Lee Show ...!" and simply changes the channel in the middle of Rooty Kazooty... Fred is upset and Hauberc embarrassed, so he changes the channel back to see Rooty Kazooty. Juno changes the channel back to Pinky Lee, and Hauberc changes it back to Rooty Kazooty.

 Juno starts to cry and sob. Just then, their Mom is coming home, so Hauberc appeals to her that his guest wants to see a show on TV. Mom says, "June, you've got to let our guest watch his show this time..." Instead Juno starts wailing "Oh, nooooo, pleeeeaaaase ..." Juno is obedient but hysterical, and runs to her bedroom cupboard and comes back in the living room with a little Doll Teacup that she is holding under her eyes to catch the tears streaming down her face ...

prolepsis 24

In a dream last night, Hauberc had been heading down to see a
friend in Saint Vincent's Hospital in the north-end of Bridgeport, a
down-hill Main Street (south-bound).

Bridgeport / transfixed to Rome/ where the thoroughfare goes
down into the ground, a steep \ descending tunnel. He looks down,
a bit frightened, into the darkness lined with interspersed lighting,
before he climbs onto the ///
down-escalator (alongside the thoroughfare into the ground..) Mini
open-top cars descending into murky tunnel darkness ---in perfect
line --- all Empty.
 now into daylight again at the bottom of the
long tube, a bright blue polyethylene railing of escalator and end
banister (bright cobalt blue)...... Through openings in the wall of the
tube along the side of the descent, across the way to the right ---
someone else riding the escalator down.

Hauberc tries to climb off to get to the other side, but begins to slip, losing his footing and his balance on the stainless-steel slope, bright blue banisters rushing up to meet him sliding down the polished aluminum surface, wondering, 'Am I on the ground floor now ?'

Hauberc gathers himself up, and is able to walk again. Uninjured, it seemed as though gravity had worked in slow motion, like in Alice's descent down the rabbit hole. At the bottom level there is the pleasant area of a boardwalk of a built-up shoreline. The waves of the ocean roll slowly towards the long shoreline of the beach below. Around a corner of billboards on the boardwalk, he walks further along and suddenly sees his friend Opal Opal Arfanovitch sitting at a table with white wire chairs in the sunshine, alone as though waiting for someone to arrive...

Hauberc shuffles over to casually say hello, but Opal motions for him to sit down with her, then turns to him and begins his next mission briefing--- But it is difficult for him to focus, still feeling a vertigo from the falling descent down the tunnel tube, also the sensation of relief at being back at ground-level, and the hypnotizing view of the peripheral glassy sea....

.....T.....U.....
V....W....X....Y
....Z....then looking around the

adjacent wall, through hallway glass partition.

Technicians were in a Taping Session: Taping everything,
all our activities that had thus far transpired --- onto a blue
and chrome reel spinning control panel: They hadn't expec-
ted to be discovered, video tape-recorders with their own
images (from previous seconds) still on the view-screens
in a tape relay loop: Suddenly spinning the
Tape at top speed, (running the tape *ahead,* forward
in time)--- He feels suddenly a new *tape-splice* warping
through his brain scanner (momentarily magnetic ions...
of the present instant) men standing and sitting
by their equipment and consoles (abruptly
catatonic in momentum) and he stood numbed......

the dream scene finally popped by old shore road
/out on roof of porch of empty red cottage by
town's river dock, and dirt road leading south
down along tide-swamped shore --- beneath grounds of
Shakespeare Theatre) across toward
 airport in the south end of town//
a policeman on a motorcycle! Opalescent
and Hauberc press themselves into the doorway
 Toppling over by himself, the policeman and his motorcycle
drown in tall beach grass (side of cottage).

101

the pilot of a small plane sputtering by overhead
looking down at the old oyster house and cottages by Bond's Dock
(Ferry Boulevard ---US1), sees them below hiding beneath eaves,
out of sight...

a snorkel pops to the surface coming together with the slow-
motion waves, coming ashore at the oyster house,
motorcycle and small Pipercub together crash against the sky
---they are still safe in their hiding place.

prolepsis 25

Out beneath the trees of this green field --- an illuminated
vision of her arrival persisted -- the face of the Sun-god Apollo in both
the Fusion of Hydrogen into Helium, and the pure orange splendor of
Human Passion, like the words of one of the Metaphysical poets he
loved, Thomas Carew -- "And Daphne shall break her bark, and run /
To meet the embraces of the Youthful Sun..."

Out beneath the trees --- he was crossing the sprawling fairways where no one played that day, then crossing a narrow golf-cart bridge over a gentle stream and through a further glen into the country.

This was a beautiful land he had never seen before : where the golf course had formerly ended and woods had begun, today the fairways didn't stop, spreading out before him to the horizon, under the glistening azure sky.

(Hmmm..?.......)

An hour of rambling into the mapless green countryside, he denied to himself that he was lost, the hour had passed into a single instant, and eventually he came to a small sign on the seemingly still tended grounds that said "BETH EL 1 MILE."

He remembered that not only had the town of Bethel previous-ly been in a northwest direction from Stratford, not northeast, rather 40 miles away./ But if only he could find a place to relieve himself..

Strange silver-golden & white puffy splintered clouds, an almost severe contrast with the blue cobalt sky, gave a haunting pause that he was walking forward into the Presence. Walking this pleasure walk now alone was bringing all the poetry back to him that had inspir-ed him in Jean Smith's and Ted Maynard's English classes. He was

walking into the fields of Elysium... Yet the scene was gnawingly Wrong --- There was still the haunting question of the "will of God..."?

Where was the protection HE should have given, after all? Hauberc wondered. Had HE ever lifted the tiniest Finger to halt this or any other war or Holocaust? Boundless suffering all part of "His Will?" A divine Condemnation of Physical Reality, or simply divine Neglect? William Blake wrote "War is Energy Enslav'd..."

In his mind, Hauberc retraced his steps back to the street sign reading "ANSON STREET." He had read the story of Anson Phelps, a prosperous pioneer of early Colonial Connecticut, who when visiting Stratford from his homestead further up in the Naugatuck Valley, later called "Ansonia," had coined the name of a triangular field "Paradise Green," remarking: "How like Paradise is this Green..." Was Phelps predicting that heaven would one day open a direct walkway ?

Now his own "colonial" ache acquired more urgency, an impending scatology that seemed the only thing more inevitable than this global Eschatology, this Final Ending ... Was this a clue that still haunted him? The last vestige of gross humanness to be released -- the end of the body? the end of the food-chain? -- Wasn't there supposed to have been a Second Coming, a Visitation of divine Grace? Could God have just allowed the annihilation of the world? Could God or Hauberc himself still somehow bypass or reverse the recent events of time? Was Time a line, an unfolding called "history" -- or a recycle of other past events? The end of Mankind was something beyond Individual death ...

Was Hauberc simply stumbling behind, when everyone else had already passed through into Paradise? Could he have been left behind the "rapture" to find the key to the Lock of Time...?

Still, he was starting out again across the fields and glades -- a road into the wilderness, like Gulliver hardly able to forget his need to look for a place to defecate in this pristine land.

Confused and hopeful, he came to a well-trodden path which approached a small old country church with an elegant marker sign before it, gold lettering on white, "BETH EL -- the little church's white enamel paint gleaming with blinding brightness, surrounded by in-definably ugly bare brown spots of hardpacked dirt paths which led away from the church entrance into the bright glades, like the spokes from a wheel's hub. No sign of life, though the grounds carried the faint smell of fertilizer.

Closeby, one path passed a baseball diamond, and Hauberc won-dered if this were the training field for a minor league team, perhaps the New World Yahoos?

(And walking further up into the country, with the excruciating immanence of Nature --- was this God's final joke? or the single flaw in God's design -- one ending point of both history and body -- a heavenly Nuclear Guided Missile poking out of His rear-end, threatening to annihilate the Human Race, Escatology is really total Scatology....

..........)Coming down from BETH EL into to a copse of birch

105

and beech trees, Hauberc finally found a small cottage with signs of life the sight making him dance with autonomic bliss and urgency --

Knocking at the door, a friendly old couple answered, seeming happy to see a stranger, then saying, "We remember your face, you're John Hauberc !" and how wonderful it is to meet one of the "leaders," even now --- "Here, sit down, have a drink with us "/ make friendly conversation.

He wondered how they could possibly remember him. Had his cover somehow been exposed in the local papers? -- "Stratford Boy Infiltrates Terrorist Cell"? or was it, "Covert Agent Leads Rebels to Destroy Thought Monitor" ?

Getting past the incessant amenities, he requested, "But, please, you must stop flattering me, and let me use your bathroom." And finally in the privy and sitting
"butforGod's-sakefuckyouclosethedoorstop-praising me"

never
alone.

Ancient Sky

The Means of Production

Prolepsis 26

He was hard at work there for months already, a factory in the west end of Bridgeport, a job given him as a material handler in the manufacturing production of ordnance. Cast back into this purgatory,

a depressing, grinding workplace, he still felt more sympathy for the others in this industrial dungeon, than his own misery at being given this secret security assignment, as they called it-- so secret they wouldn't even tell him until he had actually arrived. Rather than face a bad discharge now, he could eventually redeem his situation.

In February of last year, Hauberc had booked onboard a Yugoslavian passenger freighter, the Vicevica, out of Brooklyn harbor with his passport and some cash and travelers' checks. He was first signed on for Genoa, Italy, but the motley range of passengers – bohemians, writers, journalists, et cetera, persuaded him to change his intinerary and instead get off at the first port, Casablanca, so that he was strangely repeating his father's World War II passage on an Australian troop ship bringing American GIs to the North Africa Front, even wearing his father's still-soled combat boots. In his sophomore and junior years in high-school, Hauberc had raised his voice against the incipient war in Vietnam, a lonely responsibility, to advocate for peace, when most people either didn't care, or believed communists would take over southeast Asia. Hauberc had already read Albert Schweitzer's *Philosophy of Civization* and his essays for peace and Humanitarianism. He read Eugene Burdick's novel *"The Ugly American,"* and saw the movie with Brando in the role of a Henry Cabot Lodge character, the Ambassador in Saigon. The night before Hallowe'en last year, the news said that the CIA had helped assassinate the Diem brothers. Three weeks later JFK was killed – then Lee Oswald on live TV two

days later. What was going on ? Was this some sort of "Manchurian Candidate" plot?

But Hauberc wasn't too proud of his school work: he had had to go to summer-school to repeat Algebra after his sophomore year, then Geometry this past summer. At least now he had begun to understand Pythagoras. He did well in all the other subjects, especially English, and History, and had edited the Creative Writing journal.

So, beginning his senior year, on the first day of International Relations class he was keeping quiet, hoping to avoid alienating his teachers by coming-out against the Vietnam war right away.

Yes, "alienation" had been a conscious issue, though last school year Haubrec had made a few friends among the literary "types" -- Opal, from his Creative Writing Class, and her hip friends Persephone, who wanted to be a civil-rights lawyer, and Dayan, a concert pianist. They all met in the cafeteria for lunch everyday. He liked them all, but for Dayan he had an admiring crush since the first day in his sophomore homeroom, now two years ago -- no response except for a few precious smiles, until Opal befriended him.

Thinking about "alienation," in his junior year he had written his English term paper for Mrs. Atkinson's class, on the subject of Existentialism, on self-defined "responsibility," comparing the concepts of existence of Kierkegaard, Camus, and especially Sartre, with the weird stories of their personal *experiences*. -- So Hauberc speculated on an *Experiential* Philosophy, non-categorical and non-solipsist, and thus and Experiential Psychology. -- One early Greek philosopher, Empedocles, said there were only two forces that formed the Universe:

Love and Strife – maybe like the difference between kissing and war, or between gravity and centrifugal force? Mrs. Atkinson gave him an 'A,' but along side Hauberc's conjecture that there had there had not been any noted American Existentialists, she had noted in the margin in red ink, *"What about Paul Tillich?"*

Taking his seat quietly the first day of International Relations class, senior year, the first thing the teacher, Mrs. Carter did, was have the class move all the desks around into a circle, maybe like the U.N. Security Council....

Across he saw some faces sympathetic to his outspoken reputation, and some others he knew didn't like his "peace-nik" politics.

On the second day in this class, Mrs. Carter, an elegant looking teacher, said "Today we're going to elect a Class Chairman. I want nominations."

Someone across the room raised their hand, "I nominate John Hauberc!" The voice sounded sarcastic, but from his seat near the door to the corridor, he couldn't tell if this was a friend or a foe. A few other sarcastic skeptics chimed in, "Yeah! John Huberc!" as though thirsty for debate or to dish out abuse. Finally, his friends and others, and the skeptics too, all raised their hands.

"No other nominations?" asked Mrs. Carter. Hauberc, bewildered, had a classmate's name he respected to nominate on the tip of his tongue, but she concluded, "Well, Mr. Hauberc, the votes are in."

"This is for September?" Hauberc asked Mrs. Carter.

"No, until we graduate in June."

After graduating, he wondered if he had better declare himself

a Conscientious Objector, but delayed this decision as a freshman at the State Teachers College. Hauberc's father told him his uncle wanted him to enlist as a surveillance operator when he came in the service. Reading the history of Asia in his early youth, he had understood the difference between European medieval-trade mercantilism and Industrial Colonialism: The first was "cash-and-carry" trade, the second economic take-over of the local means of production and the exploitation of labor and resources. -- What were these Vietnamese people doing that deserved the military occupation of the French and now the huge build-up of U.S. Forces ? Kennedy had expressed his intention to give it up, but now Johnson gave his Generals full-reign, and the Military Industrial Complex all the profits they wanted to keep pushing. By now, practically every factory in Bridgeport was involved in this new "war effort," and getting rich in the process.

Hauberc had decided to take his studies forward on his own, explore all the museums of Europe, and write his own art history book and put his dreams into a novel form. He would just keep moving through countries to keep ahead of any MPs, and maybe find a lover to keep him hidden for good. The day before his ship sailed, he dropped a letter in the mail-box to notify Selective Service that he was going overseas to study.

His Uncle Simone, a General in "Army Intelligence," left him letters at all the American Express mail offices he passed through, trying to get him back "in from the cold," probably telling his cohorts that Hauberc was on his secret assignment, not a draft-dodger, trying to cover Hauberc's and his own ass. Every time Hauberc heard the term "Military Intelligence" it reminded him of Rocket J. Squirrel's

retort: "that sounds to me like a *contradiction in terms*, Bullwinkle!"

The only letters he answered were the ones from Mom, Juno, Persephone, Arfan, and Dayan, dropping them into the post as he left a city. The letters would take at least 10 days to reach back home.

Nearly a year later, after Morocco, Spain, Italy, Switzerland, Germany, Holland, and Belgium -- even Lichtenstein and Luxembourg -- he was in a sixth-floor walk-up apartment on Pont Street in Knightsbridge, London, when the C.I.D. detectives politely knocked on the door, looking for someone named Hughes. Hauberc had already met Hughes, at another friend's house, where he talked to Hauberc about having talked his way into a NATO research complex in the Mediterranean, where a psychotropic chemical was being developed to amplify soldiers' aggressive thought-centers in battle. The C.I.D ordered everyone to empty their pockets, and Hauberc was caught in this dragnet. After being thrown into a remand center for three weeks, he was sent back home by the Marylebone Court on a Conditional Discharge. Once home, he had to take the first job he was given: a material-handler in a fucking defense plant on the other side of Bridgeport, where he had to get to by bus by 7:00 AM every morning ! Triple misery.

The whole of Bridgeport had become a ordinance-manufacturing city. Defense contracts galore ! When he was hired to work for this factory, unsuspecting, the personell manager said "Welcome aboard!" and walked with his to the bottom of the stairwell. Hauberc inquired, "What are they making?" But his question was replied, "Go ahead up to the top floor, the foreman will get you started."

So here, on this factory floor, lines of long assembly-line work tables on one side of an open warehouse size shop floor, windows over looking the stone railroad viaduct passing through Bridgeport. At the assembly-line table were seated women of all ages, piecing together tiny electrical parts to be bolted together inside cigarette-pack size olive-drab *triggering cases*; and, on the other side of the room, from asbestos-sided oven conveyors there emerged a steady stream of plate-sized devices, hot with their component parts: ball-bearing beads of ste el sealed in layers of hot gray plastic that came in barrels labeled "Devcon 5" each encased in a curved, olive-drab plastic case. *Anti-Personnel Landmines.* A funny name, he thought, "Devcon," a homonym of words like the "Defense Condition" they loved to bump up higher to Yellow, Orange, and Red each time a blip appeared on the panorama-sized screen radar board of SAC. More likely the name was for "Defense Contractor" a product making money hand-over-fist for the owners of this company… Death Contractor. Uncle Simone told him he could either stay here, or be shipped to Saigon.

At the beginning end of the oven conveyors the drab plastic forms were layered in with the corn-kernel size ball-bearings by a fast-moving friendly-faced lady worker and each slid over to him to be poured over with the molten plastic from a faucet, and pressed into its mold with a curved-bottom wood form, which are fastened down with adjustable metal knobs, then the units are placed onto the oven conveyor. Gee, only twenty-five years ago the Nazis used a similar setup to destroy the bodies of their Holocaust victims.

As each unit comes out of the oven conveyor, it is picked up off the warm steel grating and its plastic casing pulled apart – taking

apart its baked layer of ball bearings pressed down with knob-handled bolts cooked into its Devcon mold. Each unit is handed off to another man who deftly uses a triangular-sided metal blade scrapper to clean away all the excess hardened glue while still warm and soft thus producing another Anti-Personnel Landmine ready to be packed for the field with a pouch of explosive powder. All destined for Vietnam.

Hauberc knew where these pieces were going when they were packed into cases of twenty-four sections each and shipped off to Fort Bragg, and the thought confused his conscience, each a black mark on his soul...

How many other souls would be stripped of their earthly garments and sent to satori at the other end of this long production route when each unit here realized its potential function...?

They were all there together, a hundred or so workers, his friends, the blacks and Puerto Ricans of Bridgeport, with the two other whites besides him running the department, the quiet kindly older Foreman Ernie Carls and his insanely aggressive Assistant Foreman "Wild Bill" Elliet. Hauberc had worked all sides, becoming the Assistant's whipping boy, who picked on him relentlessly rather than confronting the any of the blacks: "What the hell are you doing here, you dumb shit?!"

Some of the Puerto Rican men mocked Hauberc mercilessly when his hair grew back long, singing "Palu!! Palu-do, Palu !!" at him. But the assistant promoted him to the piece-work line when his worse tormentor came down with a mysterious disease, then later died of

Elephantiasis, leaving a scrapper's job open. Hauberc didn't really care much which about getting more money, but had liked being the Material Handler, chatting with the older shop women and flirting with the sexy black girls, or exploring the vast old factory complex on various errands, walking through the tunnel under Hancock Avenue along with the tow-motor operator, or through cat-walk passages above the cavernous shop across the street, above the machine-shop. But "Wild Bill" was right, this place put a mark of shit on his soul, and the blood of countless landmine victims on his hands !

 In his department, while still the Material Handler, one pretty young woman named Paquita, from Puerto Rico always attracted his attention with sweet looks and kind conversation, and while on his morning coffee-break one day, he was sitting on top of piles of boxes when his eyes came to rest on her fine face and features, some twenty feet away, and the word *"Birthday"* suddenly, loudly, came over him, into his head with a flash of light.

 After his break, he brought Paquita two crates of parts she needed for her work, and she smiled at him, asking "Where are you from, John ?"

 "I was born here at Bridgeport Hospital."

 "What about you?"

 "San Juan."

 "When were you born?"

 "1947."

 "What month?" she continued, her face brightening.

"May."

"Really? What day?" Now her expression looked slightly scared.

"The 11th. Sunday, Mother's Day."

Perhaps visibly starting to tremble, Paquita pulled her driver's license from her purse, and showed him her date-of-birth: *05-11-1947*, the very day same as his own! And with a look of furtive trepidation she gave him a quick but warm embrace.

In his deep dream each night, and also close to the surface each morning as he rode the bus across town when he closed his eyes, the same vision returned before him:

A black-caped, darksome, gaunt figure waited to greet him as he walked along a naked stretch of a treeless desolate river beach. Overcast sky and bands of distant rain clouds across the horizon dimmed the midday as the figure stood blocked his path, wordlessly gazing a mounting terror into his eyes--

Visions of oblivion and emptiness flooded through him, as though he were standing on the vast plain of the Hieronymus Bosch painting "*The Last Judgement*" he'd visited in Bruges: the painting still haunted his emotions, quickly engulfing him again into a black void, with the scenes of forgotten nightmare horrors of the dead, the slain, and the damned, tortured by demons and the imposition of impossible tasks.... until, now, here, he finally broke the lock of that stare, intense as any death angel's, and could see in the distance behind the dark towering figure, a silver-glowing alien craft....

"What is your name?!" Hauberc demanded.

Without awaiting a reply, he turned away and ran back along the water's edge and across the moor-like dunes until he suddenly came to immense black steel gates, 30 feet high... When he pushed in upon the solid doors they opened onto a different land

Even now, though, he feels the pull of that death angel's intentions.

prolepsis 28

.. . .) descending a rope ladder hung along the side of a tall oak tree above the water's edge, halfway down the thickly wooded bank from where the River Road passes, far north of town, Hauberc clumsily climbed down from his camouflaged tree-house hiding place where the thick leaves conceal the communications post and remnants of a primitive *arboreal* past...

Dressed in a stylish Harris tweed suit, instead of skins, and carrying a leather briefcase tucked beneath his arm, he scanned around the surrounding brushy woods to both sides, glancing out toward the river. The coast was clear.

Nightmare scenes crystallized before him once more, and tortured, invisible presences he could sense floating in the astral ether flashed into his view, looming before him again like torments of Hell …

prolepsis 29

At the Telephone Operations Center a short walk west from down-town Bridgeport, Hauberc is admitted under new credentials identifying him as a technical-support agent from Central Schematic, requested by Long Lines Maintenance, to handle a bug in the satellite-com relay.

The woman in charge of the section brings him to the room housing the expansive switchboard line, passing along the way through a group of young people training to be operators,who are standing around one end of a corridor listening attentively to an instructor's demonstration.

119

Among their faces he happens to see a buxom, dark-haired young woman who looks exactly like Opal Arfanovitch, his high-school friend. Hauberc has noticed this woman before in other circumstances, but from a distance, thinking it was Opal -- now even here, closer, she shows no recognition or notice of him. Not Opal ?

He continues on nonetheless, following the supervisor to a room containing a vast array of micro-relay panels alongside two large windows which stream in with bright sunshine through the venetian blinds.

He works for several hours diligently revising and altering the auto-relay sequences to rectify the communications bug that is producing a phasing effect in the transmitted signals; but he also secretly implants a timed program which will run a relay at mid-morning tomorrow, to create a window of invisibility in the Surveillance Satellite ground scan.

Meanwhile, he ponders about this Opal look-alike's presence in this facility, having been temporarily out of touch. Despite having generated their own clique of Late-Beat era painters and poets in their class, and attractive with her slight Eastern European inflection in her quiet voice, he always had some lingering doubts and strange, uniden-tifiable suspicions even about Opal herself. Still, he remains doubtful that anyone would suspect his own ulterior motive while working on this panel, for his purpose is his own personal plan.

At one point now he notices a coffee-break in progress among the trainee operators, as they pass nearby, so he discreetly moves in

amongst them and pours himself some coffee, taking his time to eavesdrop "Opal's" idle chat while slowly adding his cream and sugar.

He quickly catches up behind her again as she follows along with others down a large staircase. She even smiles at him as though in possible attraction to his glance, rather than recognition, as the group moves toward a glassed-in landing overlooking the old, stone viaduct railroad tracks, where they all stand around talking, drinking their coffee and some smoking their cigarettes.

The narrow surrounding streets of the location below somehow evoke in him the memory of the corner of streets at the top of the hill from his elementary school, perpendicular to his own street, where some of the older girls would stop to talk on their way home.

"Opal" talks to no one else, neither glancing in his direction again, though she seems to listen,and punctuates their conversations with appropriate smiles, with that same effervescent look he has seen before. She does not appear to notice him any longer amongst the other workers.

Returning to work later, he notices that the time is already four minutes past three o'clock, meaning that the people have overextended their break time and are already late in returning to their posts.

As everyone rushes back, four young people stop and ask for directions to the discotheque which they say is nearby.Although he finds this a curious request, especially at this time of day, he still is led to wonder precisely why his own Opalescent may have been planted in this group, or why she has infiltrated it of her own accord, unless to possibly intercept or originate certain calls; so Hauberc determines to stalk her and to monitor her activities through the building. Everyone

climbs the staircase again as he lags behind, carefully trying to be inconspicuous, and when he finally reaches the corridor by the operations area, the clock already reads 3:08.

The supervisor, a woman of about fifty, comes over wearing a rather peevish look, and indicates for those returning late to follow her. She brings them out through other corridors onto the mezzanine above a large swimming pool, vacant of swimmers, with blasting decibels of Rock music from loudspeakers so enormous that the surface of the water is vibrating with rings of intersecting interference *moire'* pattern.

"You'll be working in this room here," she shouts above the earsplitting blare, directing us into a small compartment off the mezzanine, a bare room with no chairs, containing old-style switchboards attached to ancient, noisily clicking digitposition mechanisms. ---There seems no escape from it ...

He suddenly remembers a dream of sitting on a lounge chair in the sun in the small yard of his parents' back yard with the telephone strung out the kitchen window, trying to make a call, but the lines were somehow crossed, and hundreds of voices were all on the line at once: not only his friends, but people he realized were dead; he had awoken in startled fear.

Distracted, he plugs two incorrect terminals together, luckily not receiving any electrical shock. Instead, over his head-set he can hear the individual telephone conversations being picked up over the satellite-com relay. He curiously samples a few of the signals, which are wired into another switching display, until he notices that all of these conversations appear to be people talking quietly to themselves, with no second party on the line.

"You idiot!" the supervisor has come running over to him, "Can't you hear those signals going out over the music system?!"

Indeed, before he pulls the connection, he can see the surface of the pool vibrating in moire' patterns with the array of voices.

"You should know better! Do you want to lose your clearance?!"

Finally, at five p.m., they are all released from this blaring audio torture, and, his head ringing, he makes his way back to the now deserted corridor, and again finding his subject, follows this "Opal" as she leaves the building. He notices an outside wall-clock now reads 5:18; he suspects the slight discrepancy on the inside clock apparently meant to shorten coffee-breaks, falsely accuse the less diligent of tardiness, and prolong their punishment.

The passage comes out outside above the railroad viaduct along the south wall where the tracks seem to be ringing still from the train that passed through minutes before...

A third of a mile walk southwest along the lower side of the viaduct, the narrow road becomes arched over with trees in full sum-mer foliage, and encompassed with small one-storey buildings of stone which seem so quiet as to be uninhabited.

By now he begins to become suspicious that this woman has known of his presence all along, moving in and out of his view deliberately, and that she is merely leading him on towards the realiza-tion of her own plan.

A short distance further, and he can see that the little road comes to an end at a little dock on the harbor edged by a well landscaped lawn; and it is here that "Opal" makes her move, taking one of the small boats, and rowing out into the enclosed little bay towards one of the yachts at anchor.

After a long time of waiting, and seeing no movement, the fifty foot sailing yacht which she has boarded has been turned by the current so that the bow is now facing the shore, and he decides to quickly take the other dinghy and row it out to investigate.

Hoping to remain unnoticed, he has soon come alongside and climbed up onto the deck of the yacht, which still seems vacant. Back on the shore however, he sees two men dressed as duck-hunters who keep looking out towards the boats at anchor. The few clouds which had overcast the afternoon have now drifted off, and he is aware that he must not only keep quiet so not to disturb the person below deck, but must also not raise his head up to peer over the side in the sunshine.

At this moment, there is a quick volley of rifle shots from the duck-hunters, and he realizes at that moment that it is too early for hunting season, something sails through the sky and explodes at the other end of the yacht, and the boat quickly begins to take on water.

Hauberc decides to go below deck to rescue the woman from the sinking boat, and instead is shocked to discover, when sliding open the hatch cover, that the inside of the yacht's hull consists of nothing but old, peeling, red-painted ribs over a rotted keel, and that the boat on its back side is not even in the water but propped on dry-dock stilts.

(From behind snow-banks on the frozen sunlit bay, Hauberc has found an old Winchester rifle in the cabin, firing it back at the hunters; until he is able to dodge his way back to shore, where he thinks he has seen Opal running along the edge of the shore...)

Behind the cloistered group of stone buildings by the dock stands the fifteen foot wall of the railroad viaduct --- and, after seeing the duck-hunters approaching, he sees the young woman trying to hide running into a dead-end alleyway and locking herself into the last door in a line of rowhouses of small, run-down tenement apartments by the water's edge, each painted a different color ... Hauberc hides himself furtively some thirty feet into the snowy woods with a view of the end and part of the alleyway into which "Opal" has disappeared, wondering whether she has found some way to get through, listening as the "hunters" approach nearer probably thinking that he has gone too.

The moment they arrive, they begin pounding each wooden door of the alleyway with their rifle butts. From inside the building he hears the young woman's frightened cries, so he begins firing the rifle at the end of the alleyway from his vantage point, to keep the "hunters" at bay. When he pauses his shooting, both of the men scramble out of the end of the alley and run off around the far corner of the building.

Once the men have disappeared down another alley, running off through the stone viaduct, Hauberc is able to move closer to the end of the alley, when a signal of "Opal's" whereabouts suddenly explodes from one of the casement windows in a cloud of multi-colored confetti...

In the sunshine, the confetti colors are bright, but when it rains

down over his head, he realizes that these are computer key-punch operators' trash from Opal's office: the IBM program card-stacks' tiny square chips of cardstock with sharp edges, which are falling down inside his collar, and sticking painfully to his skin.

prolepsis 30

In the early morning the time has come, according to the program settings he had set in the Communications Center, when he can venture outside undetected by the satellite scanner. Today he wanted to find out something on his own: whether the Church had anything to do with the surveillance system being put in place as a way to restart the Inquisition, which had been prevented from forming in America by the U.S. Constitution, and ended in Europe by Napoleon. Still among Catholics, dissent and freedom of thought was branded as "heresy" by the priests, nuns, and the devout. In religious class, he had finally figured out the favored nuns punishment for unruly behavior – to have

126

an unruly boy stand facing the corner with his arms outstretched for 30 minutes...

Hauberc had rebelled against the priests and nuns immediately after his Catholic Confirmation at 14; still but there was some sneaking suspicion in his mind that there was something being collaborated with the Military Industrialists, elites like Simone, the Knights of Columbus ... Now he could search through the official papers at Saint James with no one left to stop him!

Heading through the lower park, he walks along the path following the brook through other fields, coming eventually to the section of town just south of Stratford Center. Farther along another path, he comes out into the earliest section of town, where there does seem to be some signs of activity, finding himself walking through a tightly cloistered walled village, crowded with people dressed in the garments of medieval peasants, who go about their business amidst the sounds and smells of normal village life.

Across this populated scene of ancient life, he continues walking down Main Street, until he comes to the open-end of the courtyard of Saint James Church, circled with gray stone Gothic buildings, where a flagpole stands in the center flying a plain white flag with a simple red cross over it.

He begins to remember being in the classrooms of the long school building that line the long corridor behind the austere large "Hall" where only Low Mass was celebrated. He remembers having seen Persephone as a young teenager there at Mass here occasionally, both of their families sitting in the balcony loft -- both of them practi-

cally still children -- and the thought again echoes in the sensation of loss through his veins and the pit of his heart. This had been a fantasy: the tightly cloistered monastery they are hoping to find the way to get into the high-walled castle, but none of the cloisters seem to be connected into its corridors. A dark-haired young girl comes over to him from among the other children playing in the yard. Her silence reminds him of Persephone's quiet presence, and without Persephone's flightiness, yet there is something of this girl that perplexes him.

"Here's the passageway," the girl says, leading him to a narrow casement through the stone wall, and before he can object, she climbs into it.

He looks down into the little tunnel, and sees daylight reflected at the bottom corner...

Instead of following her, he climbs over the stairway and down the outside of the wall into the dry moat ditch. She emerges ahead of him from the bottom of the passage.

They pace downhill deeper into the Black Forest grove where the stream which feeds the moat is visible though barely flowing; coming back around the lower wall of the castle.

Into the cloister, the girl leads him into the nun's classroom where small children are seated at their tiny wooden desks --

Nun: "Boys and girls, this is Persephone and John, and they're going to tell us all about their visit to the Black Forest --" Now the scenes of the story are skittering away in his mind: a scene of running up a long hillside field clearing, climbing westward over long miles,

running to escape, tree thickets lining both sides of the clearing up to the horizon, running toward neutral territory....

Very early the next morning, a Sunday, Uncle Simone calls him and gives him instructions to investigate the report of an unexplained intense colored light that has been observed during the night in an offshore area in the mouth of the Saugatuck River in Westport, on Long Island Sound, about a half-hour drive to the southwest. When Hauberc's car arrives at the marina dock, he is taken aboard a Navy motor launch with four scientists and six heavily armed sailors. In the overcast dawn light, they slowly approach the light source that they see in an isolated spot near some marshy islands.

The light becomes almost blinding as they hesitantly approach, so that they can see it in the shape of some kind of craft: a large disk-shaped light, floating in a stationary position, scintillating with mixed metallic light -- red, blue, amber, green --

Coming alongside the light-form which does not look solid, about 10 meters wide, rounded on both the top and bottom, the launch actually bumps something smooth and as hard as polished granite, but

which they are still unable to see. Two of the high-ranking Navy scientists ambly climb up onto the side of the invisible object and begin tapping, feeling and examining the contours of the hard surface with magnetic and radiological instruments. Finally, the transparent object emits a soft opalescence.

Meanwhile, the others still in the launch have pushed themselves back from the side of the thing, and begun to float off a little way in order to circle widely back around the far end of the marsh island ---

Approaching the "object" again and again in wide circles, all they are able to see of it are the same intense speckled colored lights in which the scientists are enshrouded. On the fourth time around it, swinging back from the far end, they see the craft suddenly fading into transparency again, and suddenly vaporizing altogether --- leaving the river mouth in utter silence. The two scientists had disappeared with the light-object.

Back in Stratford by late-afternoon, Hauberc receives another call from Uncle Simone who now tells him to report on a situation that has been called in from Paradise Green. When he arrives there he finds an uproar of two dozen people, standing around the wide sidewalk of the line of stores, staring west across Main Street at the wide triangular Green. Among the pine trees in the middle of the widest end of the triangular green appear the same kind of speckling lights as he had seen earlier in the Saugatuck mouth.

Walking down to Vic's Variety Store in the middle of the block and he eavesdrops on the conversation between Vic Musante and the other old-timers, though their statements are strictly factual to their observations.

Standing on the sidewalk, however, Hauberc asks various pedestrians how long they have been there and what they have seen ? No one here wants to offer any observations to anything so fantastic as what is actually visible across the road, with the same quiet response from each, "...I don't know..."

He crosses the three lanes of Main Street to Paradise Green, attempting to get a better view before deciding whether to approach the object. The glaring luminous light flickers intermittently, and he is filled with a feeling of a fear that seems to come from an ancient and secret power ---

Steadily walking toward the object, shielding his eyes, he thinks he can see two figures standing upon the side of the oval light, confirming that this is the same craft as they had approached in the launch. Getting closer still, he is able to discern that two of the figures are the Navy scientists, standing dumbfounded as still unable to believe their transportation here.

He is hardly able to believe the sight of the three other forms standing atop the object: Bathed in white radiance, he must wait until his eyes are able to adjust and withstand the glare: they are garbed in silvery robes, their faces sparkling with dazzling colors, swirling in contours around four center points, one on each of their foreheads, two in the position of their eyes, and one at each throat.

One of them lifts his arm pointing toward Hauberc, for the scientists to go back, and they then seem to mentally transmit an incomprehensible kind of greeting of spatial travelers and the warning and the gift of the "Splendid Lights"

"Witness the Radiance of the Seed within your own earthly skins---"

As the two scientists slide back to the ground, Hauberc is surprised at their abruptly cheerful expressions, He glances back to see the light once more as it turns transparent and vanishes from sight/

But walking back home alone, down the first side street from Paradise Green east back towards the pond, Hauberc abruptly comes upon a strange spot of pale green light on the road, which seems to hold in place before him as he tries to move forward, as though tracing and checking his steps, the small pool of light of a beam of green light which comes out of the dark, starlit sky from a point almost directly above to the east, as though a ladder came down... A ladder of green light which recedes backwards from this spot and withdraws straight back as he walks over the black asphalt pavement of the next street, then slowly back up into the sky, while still scattering its fading green in speckles over the face of the quietly rippling water of Brewster's Pond, then goes dark..

prolepsis 31

Called to the upper floor of another annex of the factory complex where he is working, Hauberc is ushered into the luxurious office of General Simone, the Director of Strategic Command (which he habitually calls in his mind "Subliminal Command"), invited as soon as he had reported the two incidents he had witnessed last night.

When he arrives at Simone's office, he suddenly wonders whether he might be being called to account for the episode with Mr. Stuffington's yacht. Soon Hauberc is announced and quickly brought across the plush thick-pile carpet by the reticent secretary to Simone's large desk, where nearby a visitor sits on the white sofa.

As he walks into the room, Simone is speaking with the unusual looking man, whom Hauberc hears asking "Has the Opticom program on the reactor been initiated?"

"Sir, I've come to report what I've just seen," Hauberc says, wondering the meaning of what he has just overheard, as Simone seems to lift his hand to curtail their talk.

"Excuse me, Hauberc, please meet Ambassador ME, the Emissary to Earth from the Prolepsis Nebula..."

"Me, this is one of our special operatives, Captain John Hauberc. His father and I served together in the O.S.S. in our World War II."

"I am honored, Mr. Ambassador. I have always hoped to meet someone of extra-terrestrial origin..."

"Well stated, Captain," enjoins the ambassador. "The recognition of my presence will be a delicate matter for many on your planet."

Hauberc is surprised to find ME's features quite humanoid in appearance, though refined as any dignitary, causing him to wonder if this person is with the agency that he had battled on the catwalk complex or perhaps related to the impostor.

Hauberc returns the flattery with diplomatic curiosity and interest, then finds a seat close to their conversation, sitting in a great leather upholstered chair by the coffee-table, by the plate-glass window overlooking the city...

The silent secretary brings drinks for all three, scotch for the General, a tall glass of tropical fruit juice for ME, and mineral water with lime for Hauberc, slightly sour.

The two have gone on discussing various recent events from the world news reports, and Hauberc notices that Me displays a curiously ready knowledge of many details. As he listens he begins to feel slightly queasy with the import of this development, taken so easily in stride by Simone.

The secretary suddenly returns with another tall glass of mineral water like the one she has given to Hauberc, and places it on the corner of the coffee table exactly equidistant between each of them, so that they each must wonder for a moment for whom it has been brought.

"Ambassador ME," begins General Simone, "we on this planet are faced with a critical problem...This glass of water. The water it contains has been extracted from one of the deepest aquifers, or underground streams, on our planet, thousands of feet below the ground. Like several others we have tapped into from each of our continents, we have discovered that it now contains the radiated heavy metal baltholium-G, accidentally released by the development of a powerful Neutron weapon. The benefit of this weapon would have been the biological neutralization of the enemy within a fifty kilometer radius, without any destruction of the infrastructure, and a limited half-life of twenty days..."

"However," Simone continues, "though not all our aquifers have been charted, and we are now certain that if this radiation is allowed without antidote, the population of our planet will soon die."

"General Simone," responds ME, "we do not possess the antidote you seek – but we are aware of a race who call themselves Dropsies who mines a substance that neutralizes baltholium-G which they use as a catalyst in a primitive metallurgical alloy. We can provide transport for a scientific staff to that planet and offer to negotiate for you to obtain that product..."

Hauberc becomes aware of a peculiar feeling in the air, the sensation of an emanation that seems to carry its own tonal sound, a single note subtly floating in the air, with which now and again the conversation resonates, then with other notes perceptible on deeper levels, of quieter octaves. He is unsure of the source of these tones because of

the blending effect, indeed the possibility of sources, past, present, future, or other worldly, simultaneous...

The possible reversal of Time, the possible reversal of words. Hauberc finally fathoms the etymology of that name "Time"— a comprehension: a pre-capturing by the hand, or a rhetorical device to usurp another's idea.

But for one note of dark dross-ness, that he had never before detected here, the sense seems more attached to the place, or to the land below the building, forty floors below...

"Does he drift away like that anytime?" asks Me.

"What do you mean?" responds Simone. "What's wrong, Hauberc?"

Hauberc leans forward over the coffee-table: "I apologize, Sir...Was there once any kind of an offering here ---?"

"Possibly," answers Simone, "There were some broken down ruins with an altar uncovered on this location when they first built here in 1801. They overbuilt the site, but put away the fragments with inscriptions. Our ethnologists have identified the writing as Phoenician. I've seen the stuff."

"Pre-Roman, here?"

"They've only been decoded in the '60's..."

"So you've been visited before, so to speak" smiles Me.

The unsettling feeling persists and suddenly intensifies into pain.

"No, it's something else, I'm sure..." Hauberc wonders aloud. "Ouch!"

General Simone and Me both glance at his glass, then quickly away.

"So, Captain Hauberc," says Me, "You were a witness of the event at this place called Paradise?"

"Can you tell us what happened, John?"

Suddenly an overlapping transfiguration takes possession of him, his eyes automatically closing over into the vision, red yellow green orange sun prismatic gleaming...2-dimensional spiraling outward cyclone overlay ...

... a herringbone pattern --

A Technicolor cartoon rabbit-like creature, something symbolic of his own flight impulse, (upon a yellow-green backdrop) stops to dig up a carrot along a row of garden vegetables, but is pounced upon by a huge Rat

The Rabbit, before the yellow-green graphite mosaic, is racing to the right on the wide view-screen/ bounding darting speeding away faster and faster until the form becomes concentrated into a ball, smaller and tinier into microscopic dimension, its velocity searing its path ahead, transforming it into particle size, into a light photon, into a quasar signal...

Book Three

Inferno Earth

PROLOGUE TO CHAPTER ONE

Hauberc was suddenly; sitting across from the guard's
silently in a chair in reception desk
at a friend's London flat --Street of Madrid,

looking out the Neo-Tudor ---Street of New York,
window on his right transposed to the site of
 an orange-yellow flaring,
---the sky becomes a screaming furnace vortex red
chasm: negative,
 -- Hydrogen bomb Ground-Zero --

flowing mutation
through trans-dimension Picadilly; soldiers, police-
 Time-Space Continuum: guards uniformed stride
 along,
 colorfully reality structure molecularity---ash vortex..
all under control.......
 through into total 4-dimensional molecular
 red-blue-green costumes
 shift, Reality Hold ? But he'd always
 readjust thought this time ---
 Later, he looks outside to yellow-fading orange-yellow,
 through another corridor another part of the city, Juno
 comes carrying a heavy sack, places down her burden....

 In the late morning standing (waiting) on the other side of
Paradise Green --- across the diagonal triangle of lawn at the forking
of the road to Huntington......

On the west side of Paradise Green, the church with long white enamel walls now lay in ruins, the building had collapsed into its field-stone foundation.

--- Singed steeple beams,

embers fallen inward, letting through patches of clear blue sky ---(how did this happen to this one building ?) --

Staring at the still smoldering top beams...

Up the once long-ago known hill, Hauberc passes by an immense building, an old Victorian style apartment building.

(A ten story cubic block structure, with many windows -- but he's sure that the building was not here before.

prolepsis 32

On a bicycle that he found laying unlocked on the ground by the door of one of the stores of Paradise Green, he rode down Main Street, looking for any signs of life or even death...

The radiation had already reached its half-life even by the time he got back to Stratford, and it appeared that the Neutron Bomb had left all buildings intact, but had not only neutralized all metabolic life-forms, but somehow had the effect to bring about rapid total disintegration of the corpses, leaving only piles of rags which had once clothed living beings. But he wasn't convinced that there was no one

left behind: there lingered a peculiar sensation of being watched, as from far above, by some malignant force, foreign or domestic, and also the wonder that there were others like himself who had survived or filtered back in, following the event.

It was a nice dark-blue 20-speed racing bike that he had found there, and he set off heading south down Main Street, all the streets empty. At the large intersection of Main and Barnum Avenue which had become US1, he turned right to head the bicycle west up the long slope of Barnum toward Bridgeport, past the ice cream dairy and pizza restaurant on the right and Weiner's wide used car dealership and then the duck-pin bowling alley on the left, then down the slow slope of Barnum Avenue where a vista of the old industrial city of Bridgeport spread out before him, with its worker-housing neighborhoods, and array of 19th century and World War I era factories sprawling across the landscape ahead of him.

Past Franklin Elementary School on the left and the large Holy Name of Jesus Church on the right, he rolled down the long grade of Barnum where US 1 forks off to the right on Boston Avenue, but straight down past the Italian deli and Candelora's appliance store, he reached the run-down old Martin's News Stand on the corner of Bruce Avenue, usually open 24 hours, now deserted and dark. From here, he turned left to head southward, down towards Saint Michael's Cemetery. Several blocks down the street, as he passes little brick warehouse and factory on the right and left, he is about to pass under the railroad viaduct when he begins to hear a rumbling coming down

the track above from the left to the east:

In amazement, he watches a beatup-looking diesel engine, with its tall red & black on white "NH" extinct New Haven Railroad markings, very slowly come over the viaduct bridge, but is too dumbfounded to to signal to the engineers in the cab high-up. The engine is followed by sixty or seventy freight cars, boxcars, coal-carriers, and tank-cars, giving him time to climb the three-foot high stone blocks of the side of the bridge and grassy knoll to stand along side the tracks where he sees the caboose coming, which, after near-ly ten minutes, the caboose slowly trundles by. Now he waves and loudly shouts to the brakeman who is leaning out of the upper caboose window, "Where are you going? Where are you coming from?" But the brakeman, in his dirty coveralls and pin-striped rail-man's cap merely looks down and casually waves to Hauberc "Are there more survivors?" shouts Hauberc. But the caboose passes and continues along slowly heading west.

A short way further, Hauberc comes down to the intersection of Bruce and Stratford Avenues, where the traffic light is still somehow turning green, yellow, and red, though no cars are about.

Straight across is the wide open gate to Saint Michaels's Cemetery, where his grandparents are buried, but he wonders if he can catch up to that freight train, so he turns right to cross the city line into Bridgeport, pedaling through another now-desolate factory area, and what was a trickier, more dangerous neighborhood of the East End of the city. Eventually he passes the corner of the crumb-ling massive Carpenter Steel Mill complex, and crosses the Stratford

Avenue Bridge over the Yellow Mill River, by the old Amoco Station where his father used to stop to chat with old Army buddies, then soon past the site where the vast creepy Shopper's Fair building stood before the Connecticut Turnpike went through, then by the fish market, also where his mother had brought him many times, then past where the Port Jefferson Ferry wooden covered pier had once functioned, then over the Pequonnok River Bridge. Hauberc suddenly remembered when he was really little, sitting in the car on a hot day while his mother ran into the awful Shopper's Fair for some fabric, and on the radio came the voice of "The Old Philosopher" lamenting the sad catastrophes of life ... "Is *that* what's got you down, bunky?" Then, "Rock 'n' Roll ?? – *will you shut up*!!?"

Across the Stratford Avenue Bridge over the Pequonnock River, and under the railroad bridge, on the right, just next to the red, white and blue-striped pole of a barber shop built under the bridge, a two-hundred-red foot long concrete ramp went up from the street-level to the run-down large 19th century, stucco building Bridgeport Railroad Station all in faded pale-green paint.

There was no sign of any freight train by now, so he kept riding, coming out from under the tracks to turn the bike left along the bottom of the gray-stone viaduct, and down a short ways to where the old doors of the meat packer and market had been left open. Where he used to go all the way to the back, over sawdust floors, past hanging sides of beef, to buy sausages sold my men in red-stained long white coats, now was devoid even of the swarm of flies he would have expected, had not the radiation previously neutralized

all. Hauberc continued pedaling through the desolate downtown Bridgeport center, seeing nothing more alive, heading west on Fair-field Avenue by large building department stores, hobby shops, and the old movie theatre. Hauberc mused here of the dance studio up-stairs here where Mom used to bring Juno for her lessons when they were little kids, Mom apologizing to him all the time to make him sit and wait the hour – while he silently admired these budding girls in their black leotards and swirling long hair....

He continued, pedaling past the still-running fountain crossing Park Avenue, and the massive Klein Memorial Auditorium, until, feeling tired and hopeless, he comes to the Fairfield Avenue's inter-section with Clinton Avenue,, where forks to the right, cycling up along the row of elegant churches both sides of Clinton.

The daylight was well past its peak by now, and he needed to start back for home, what was left of it. – But here on this street lined with churches, another wonder came back to him: He didn't know whether he would believe in God ever again, but he decided to go into the lovely Greek Orthodox church there and light some candles, perhaps still believing in the power of prayer, a conversation with something out in a peaceful universe, unlike here on this stupid planet. He found some candles still smoldering, and took a stick to light others…

But there was something else in the air, a fetid smell, as he walked back out of the church and there it was, two actual corpses lying in one of the rear pews. This was not one of the war casualties, but a

145

survivor casualty – and the fear struck him again -- was this the kind of death, a further sickness that he still must fear? But now he realized there were bloody bullet wounds in the chests of each of these bodies…. What the hell had happened to *them*?

It was late now, and he decided that the next day he would ride a different path – down to the campus of the University.

prolepsis 33

Merging into another furtive night, the sound of far-away explosions inexplicably rumbled again across the surrounding horizon, through the void of what once was. Under the dreamy world of past sensibility, Stratford now began its quiet hours under the surveillance Opticon. The Communications Reactor had been disrupted once, but it was something more deadly that was now imposed in its place from outer space: motion-detection down to the square inch of Earth's surface, something that sensed any activity after dark, and leveled a paralyzing laser on the subject. Now dead forest animals and feral cats lay about.

In this late summer evening, there were only minutes left before the Opticon curfew would activate again. Now Westin, Hauberc's techno compatriot from his time in London, had gotten back to Stratford again and made it through one of the decrepit pre-Civil War "Underground Railway" tunnels that laced under the town and connected the sub-cellar of his family house with Paradise Green, a half-mile west from here. Westin tells him he has tapped into the surveillance system, and detected something moving on the other side of the woods. Hidden survivors?

The daylight is starting to dim out, as they walk from Hauberc's house down from the end of his street into the cleared playing field that used to be scrub woods. Through a grove of elm trees they cross the old, unpaved carriage path that cuts through the woods, then climb up onto the quarter-mile wide wooded rocky schist outcrop that runs north-south from Allyndale Drive to the Long Brook Park, now almost overgrown with brush and trees. This was the stomping-ground of his childhood that he had hoped would never be built over, still spared... From here, a narrow path goes along the rocky outcrop fifty yards to the north then down out of the woods onto Allyndale Drive at the bottom of the street hill. Here they circle around a corner to the right onto East Parkway Drive, a little street which runs along the base of the grassy hill with tall trees on the opposite side of the outcrop, to just where Laughlin Road East, the disconnected eastern portion of his street runs down to East Main.

"It was this house," Westin indicates a small Cape bordered by

a white picket fence, on the corner of East Parkway Drive and the extension of Laugh-lin Road on this side of the woods. The daylight is fading out faster, as they were are now in the shadow of the rocky and grassy hill. Now there were no usual residents switching on their inside room lamps at dusk, all gone; but under the dusky-blue sky, it still seemed eerily familiar, not far from his grammar school. On these streets he had once fruitlessly tried to make friends with the hostile kids who lived here on Laughlin Road East, who had later bullied him in 6th grade and again in his first year of middle-school. Twilight and scarlet now faded over these now empty houses.

But there was suddenly a faint light coming from a small basement window of the little house. The light from inside may have been a single candle being lit, before the little casement had been quickly covered by someone to keep themselves hidden.

Westin and he had crossed the empty streets from Hauberc's house like a perilous sea -- the failing light's sense of past time persisted as the impossible presence of curious eyes; as words in the mind had deconstructed, phrases already dissembled, like the vacant state buildings they had destroyed last night, so never to have them filled again with torturers and spies.

No emergency vehicles would respond, nothing in an empty world but a schizophrenic game of wishful persecution.

Over the hills behind imaginary cannon lines, on a street bordering the far edge of the woods from Hauberc's parents' house, *"There! Did you see that little light?"*

"Who <u>else</u> could be left -- ?" crouching silently at the edge of the low, veiled window -- all else was only a veiled world – They were taking a risk of both satellite detection and armed defense from inside, but he bravely tapped softly on the glass of the little window by the ground. And small fingers to pull the curtains apart from inside; two young faces, fearful young girls' eyes.

They just as bravely invite the two young men into their dim sanctuary, and four pairs of almost-lost eyes meet/ a comfortable roo m, a blue scarf covering around a shaded kerosene lamp...

and no words possible

Minutes lost ground, sitting all together, then Westin, looking exhausted, disappeared with one, saying "I can't keep my eyes open..." leaving two from four.

The young woman looks quietly at Hauberc from across the table. "You were at the raid, weren't you?" she asks. "Westin didn't remember my sister or me, either --"

"I think I do -- But weren't..."

"It's all over now. No one can communicate anymore without that computer, no countries to make war -- We don't even know what's been destroyed --"

"There's nothing at all on the short-wave bands, nothing, but something watching us.."

"-- Except we have to learn all over how to talk to each other," she continues, "and not use words when they don't apply.

Words without soul can't lessen the pain we each have to face, just still being alive."

Hauberc is moved but now silent. After a long wordless moment, she reaches her hands across the table to find his, and says softly, "Come, if you want to sleep...come."

Her body is warm to his, and there is no strife or motion, only peace and sleep, as she rests his head to her soft breast.

Days had gone by in the sanctuary of hidden rooms across the hill woods. They slowly awoke in semi-darkness. Night was beginning to fall. The desolation of everything, outside of the sensations of their own bodies, slowly began to engulf their spirits. In these abandoned rooms, the two couples lay still for hours, listening for any sign breaking the silence outside.

With no electricity, but some water pressure, they rose and bathed two-by-two in the luke-warm large tub, and slept with the cycle of daylight.

Though there were now more things needing to be done, they must wait for tomorrow. After a long time, Hauberc's lover finally says: "I can't stand living this way. How long do they think we can go on with no music to listen to?"

Walking boldly in the daylight of deserted streets, hoping that the thermal surveillance satellite would assume them as vigilantes, Hauberc led his lover across the woods to come around to the lower end of Brewster's Pond, down the stone steps where the water flows to the left beneath a small stone bridge and down over a low waterfall through the lower valley of the park. The trees around the widened brook and shade and sparkle the sunlight -- Instead, they walk to the right, on the sidewalk edge of the pond along the base of the slowly curving stone wall towards the wider expanse of the pond. In the suburban park, they lay out together on the grassy edge of the pond of the warm afternoon until the sun set across the surface of the water. Now Hauberc led his lover back again to the narrow necked end of the pond, back up the little flight of stone steps and along the houses Elk Terrace, a suburban street lined with the stately elm trees which remained past the Dutch Elm Blight, though now few humans were so fortunate..

He had remembered a friend's room, who had had a high quality battery-powered stereo turntable, and a vast collection of LPs, with Rock, Jazz, and Classical music.

In the upstairs bedroom of the third house from the corner, they could now hide in this empty middle-class home, a white-painted

151

colonial. He knew this house – as this had been the room of a friend named Ted, one year older than he, and he had been here once. For days and nights they listened through large matching head-phones, playing LP after LP of Ted's former collection, until they exhausted Ted's large supply of batteries. Outside, the satellite thermal scan still monitored the area outside for any activity.

Days later, now hopelessly peering out over the window sill over the black shingled garage roof, he viewed the lines of white houses along both sides down towards the park at the end of the street. From the other window he could also see across to both ends of the pond. His lover whispers for him to climb into bed next to her and they quickly fall together into weary, hypnotic dreams.

What was her name ? He couldn't remember. Had she even told him yet ? Just before dropping off into sleep, he remember-ed visiting another house further along on the other side of this street, the narrow one with the nice little porch. He was 7, and his little girl-friend was 7 too, with long blonde pipe-curls. She lived in Hartford, and was visiting her grandparents' here again on this warm summer Sunday. They had played quietly all afternoon together, walking to-gether along the edge of the pond, around and around it several times, then sitting on the grassy knoll beneath her grandparents' house, holding hands and as the sun set over the still water. When it was time to go in, she wanted him to come in, and they sat in the living room with her grandparents watching TV. She had sat back on the sofa, and made him sit across so his head rested on her lap, and after a few minutes, kissed his forehead when it was time for him to go home.

But again Hauberc awoke, and now realized where he really was – still lying, stomach-down on the cold, crevissed ground, alone, in the narrow passage between two garages.

prolepsis 34 THE DELUGE

Before waking, he was walking around the corner of Charlton Street and Laughlin Road, along the front walk in front of his family house there on this sunny morning. He turns into the carless driveway of the next door neighbor's gray house, and walks up to the Customs Desk (propped on orange-crates in the middle of the concrete driveway).

 ---"I've come to enquire about renewing my visa.."

 The Customs Official standing on the opposite side of the crate looks up and stares at his eyes, a blank expression.

 the row-boat had landed scraping the rocky bottom under pounding surf, furtively coming ashore by the quarter-moon of a palisades night shore.

"How long more do you wish to stay in the country?" the Customs officer asks looking sternly up again from his orange-crate desk...

"How long can I stay?" He wondered whether his clothes after washing, still smelled of the sea ? (The younger sister had told him to undress when he came in.)

"I'll ask the questions, sir!!"

After a pregnant pause: "Well, I think we can allow you one week." (That's not even time enough to make affordable airline reservations, he realized.)

Floating on a raft in and out of a mouth-of-river cove--- sitting eye-level on the flat-topped Housatonic River, swelled by alternating days of heavy rains going on for weeks;

the Infinity Plane Surface, all dimensions expanding upward from eye-level (and into cove-Shored Worlds, all object absorption dimensions --

The boat brought them to a pleasant garden at their friends' home on the Milford side of the river, to an outdoor wedding cere-

mony of a distant cousin, all the guests were dressed formally on the warm day, and the dinner accommodations were already in place: serving tables and twenty dining tables under a large wedding tent with a long view of the wetland meadows.

But the pleasant sunshine gradually became mixed with the pretty nimbus clouds passing over again, leaving shafts of yellow light here and there,and the wedding party was finally rained upon and moved indoors.

The rain had become heavy, and when they were driven back and arrived at his Mother's house on the Stratford side, they had made coffee and put out pastry brought home from the wedding left-overs, everyone chatting until it got to be late in the evening.

....''We'd better all stay here tonight,'' another young woman friend of the family was later saying.''...The radio is saying there are trees down every-where, and there's lots of flooding in low-lying parts of town.'' Outside the rain was now pouring down in torrents (as it had intermittently done for the past Forty Days), and the storm winds growing stronger yet.

Very early the next morning, 5:45, he awoke knowing the dog wanted to go out, so went downstairs to let the beagle go out-doors, through the French doors of the living room... All the other women of both families had taken the beds in the upstairs rooms and put out extra cots all in the same rooms. It was still coming down out side and the beagle dashed across the soaked lawn to the shelter of three oaks.

As the only male in the group last night, he had been given his

late grand-father's room for himself. But walking back through the living room in the still faint light, someone sleeping on sofa, was sitting up as he walked by, with the blankets pushed well below her chin: the dark haired, petite, now grown daughter of his mother's childhood friend, a year older than he, and he could feel her eyes following him across the room, her squinty kittenish face that he had always felt shy affection. But now she was trembling.... But with continuous eyes, she silently beckoned him to lay down beside her –

......5:45 on the luminous night-table clock face when he really awoke, to meager daylight beginnings......But tinkling gurgling drain-pipes recall the terror-waking thought-----

It's still raining !

Walking past the living room into the TV-room downstairs, to where his mother was napping on the large sofa --

She wakes to see him enter the room, asks --- "Is it still raining?"

.......In the later morning, they called him to the view through the upstairs front window: looking one block north, over to the middle of the next parallel street block which was Allyndale Drive --- across back-yards of other houses: The water-heavy ground has caved in onto a subterranean lake, the *sink-hole* cliffs sliding inward to deeper levels--- And edged around on the opposite side of the hole is the single foundation of one of the houses, a large many-

roomed gray house with windowed sun-decks around the first and second floors -- now with its cross-beams of toppled wreckage dangling into the sink hole ----

In his parents' house, in the present tense -- now, rather than before. The house was darkened.....empty but for his sister Juno. But her behavior was strangely quiet again/ her eyes dazed, but never so to communicate with him -- so little more to be gathered. She had been sitting for hours (a silent shadow) on the arm of an overstuffed living room chair, her feet in the seat.......

He had spent hours in the attic alone until night-fall, watching with the binoculars out the windows over the neighborhood to the west and east over the woods for any sign of movement or activity. Finally, he came down through the heavy weighted hatch-way door which had been leaned back open all day. Why did he no longer feel safe, past dusk, the same feeling of unsettled entities coming down the stairs to pervade his room and his dreams.

Everyone else was long gone -- Juno was already sleeping, in the darkened house, her bed moved to the center of her room.

As he came downstairs through her room/ he kneeled by her pillow to watch her ---

Her breathing was irregular (none for minutes at a time) she was Juno though.

No longer a young woman, with the dreams of the life she was preparing for: a home, a husband, children, a profession -- she was now the small ten year old child, pudgy and tomboyish, but prone to sudden tears.

At that moment as he watched, her eyes flicked open, saying, "Did the world really end in twenty minutes, like they said it would? Everybody's gone, did the atom bombs come when we were sleeping?"

She was back to sleep, turned away, before he had any answer, and he finally went to his own room, glancing again out the window (the cannons down in the woods had been pulled back by now, only muted blackness).

So he undressed and got beneath the covers.....

His perplexed eyelids still sticking open kept him restless (nothing would happen if he remained awake), until he was awakened to sunlit linen sheets. --

Late around midnight the next night, his older contact Woldomir K. has sent him to hide in his safe house, a cabin on the shore of a small cove, where climbing a darkened flight of stone steps Hauberc realizes he has stumbled into the large bedroom of Woldomir's two daughters: strange, young blonde sisters, the sound of their voices telling him they have sat bolt upright, startled out of sleep, in their L-arranged twin beds.

"Is that you, John Hauberc?" one asks him in the dark, the voice of Najia, the older of K.'s daughters, around 20, who had met his boat landing earlier in the evening. Stumbling in the dark, he trips closer to sit on the edge of her bed. In the faint shadows, he was almost sure he could see her nakedness, her breasts nearly glowing in the deep dark, as she slid back under the covers, talking quietly with him while she drifts back into sleep.

........In the dark, he could see only the eyes of the much younger sister, Elainya, on the other bed, until her soft voice says: "I've dropped my book onto the floor. Can you come and pick it up for me?" He bends out over the edge of her bed and reaches down, into the inky water of the palisade-shored beach ---

Feeling his body pulled to shore just in time, the row-boat crash-es onto the rocks into pieces -- He brings up and opens an oversized book ... Hiding herself under the covers, she snaps on a tiny little reading bulb inches above a flow of golden hair, "Will you read it to me...?" It is an oversize book about dinosaurs, with

illustrations of prehistoric animals, that he opens to the page of a
huge-winged prehistoric bird sweeping into flight

.... a red-ink sketch

----"Pteranodon"

He'd requested a special trip home from European operations
just to see his dentist, but was instructed to avoid the Immigration
authorities, and finally had come in by rowboat (dashed onto the
moonlit rocky shore).. He had to quickly locate his old friends
before being ordered back. (For some reason, the dentist was not
able locate his file chart, so took all new X-rays.)

Riding on a bicycle through The Fenway, two days later,
trying to find Dayan, it seemed that Boston Conservatory had expand
ed again, the new buildings looking more and more like Harvard, the
interiors a little like his high-school--- Everyone gave him curious
glances, as though reading his actions and puzzled by the degree of
his intent.

All the campus buildings were spread out around a wide central court-yard of grass and trees, with wide glass doors opening onto it from the building corridors. But no one he asked knew Dayan or could tell him where she was...

Across the court-yard, riding up into a corridor high-speed lane (though somewhat crowded for a bicycle), a corridor looking like the one near the admin office of their own modern high-school building ---stopping at a small rise of steps almost colliding with Linda Plum, a sweet friendly face from his home-room class, as was Dayan, so now he *knew* he was in the wrong place! Linda was surprised to see him, but she told him where Dayan was: So back around the corner, he waited at a spot where Linda said Dayan should be passing at 11:45 on her way to her Harmonic Theory class He reminisced, as he waited for her face to appear around a corner, of the following day when they had jaunted through historical houses in Cambridge, harmonizing the Beatles' songs, "Eight Days A Week" and "If I Fell In Love With You," their voices weaving together in counterpoint ---

But another year later, when their moment came close again, he was awakened the next morning with the clock-radio, an early June Monday with the first sunlight coming in the window when he opened his eyes. This previous evening they had finally really kissed in passionate earnest -- and he awakened from the sweet dream of her hand still softly touching his face, as he drove the car, taking her home, down the River Road, Sunday night --

161

But the clock-radio the next morning had awoken him with the first reports of Israeli jets upon Cairo and armored Israeli divisions moving into the Sinai. It was the sobering fear the "greater conflict" would erupt and re-invoke the guilt in them and impossibility they would forget in the pleasure of momentary fulfillment, at least in his own mind... He had remained her close friend five years already, hoping that she would one day recognize and feel the depth of his feelings for her, and realize herself why she had sought his friendship for so long.

Yet again at 10 before One, he was standing in another spot she was supposed to pass after her class -- but nothing, still.

It was like that same thing again: that morning in Boston when she had finally greeted him with a fleeting hug, after forgetting his arrival the previous afternoon in an unknown city on her written invitation, "before you leave for Europe, come to Boston to see me."

Back downtown one year later, walking in the middle of a busy street ahead of him in a rundown section of Brixton in the south London, he was sure he recognized his Surrey friends Gary Barton and Dave Leedham, whom he had met at the Hotel Royale on the Rue de la Plage in Tangier and again at the Far End Hostel in Gibraltar, where they had pointed out to him the

monkey colonies in the cliffs of the Rock. With these friends, he had traveled to Malaga aboard mountain busses.

Leaving Gibraltar, they had passed through the Spanish Customs Booth at La Linea, and begun hitch-hiking east along the coast. But after after ninety minutes of no one stopping, they had flagged down the bus. Riding on the side facing the coastline miles along the Mediterranean Sea, Hauberc was puzzled for a while by the bright colors of reds, yellows, turquoise, and browns which lined along the sunny waterline, before realizing he was seeing coral reefs for the first time.

Arriving in Malaga, they walked with their backpacks to the address of the Youth Hostel there, but the lady in the small office told them the hostel had been closed. Instead of beds here, they were given an address on a piece of paper. Finding their way there and ringing the buzzer button on a gold occupant's panel they were invited up six flights of stairs to a large apartment, where they were given a room with three narrow beds, and fed a dinner of sweet potato soup and Spanish bread. Waking in the dark hours later, they realized that the wooden shutters were closed so tightly only a slight crack of daylight came through. Throwing the shutters open suddenly flooded the room with bright sunlight and a view down over the city of apartment buildings and rolling mountains off in the distance of the horizon. Determining to hitchhike to Madrid, they set out that afternoon walking and trudging up the highway to the north which led to Granada and Madrid, with their thumbs out to every car and truck that infrequently climbed the hill and passed them by.

Finally, at 6 PM, they gave up the idea to hitch, and walked back down the steep hill back into the city and to the central Train Station, to take a train to Madrid. At 11:30 PM they found an empty compartment in a Third-Class carriage. Within minutes more young fellows also carrying backpacks crowded into the wood-bench seats of their compartment.

On the next track, a modern express train started out a moment before their "local" train finally lurched forward on its way. As the old train crawled forward, a middle-aged Spanish woman and an older man also crowded in to the compartment, squeezing themselves opposite one another into seats between the already exhausted and sleepy array of young travelers. Seeming suddenly nervous to be surrounded by all these young men, the woman started talking to her older male friend, and sounded to gossip in unintelligible Spanish all through the night. Quizzical looks to the Spanish fellows in the car only drew puzzled looks in return…

Months later, he dreamed in his exhausted sleep in the slow train, that he would be in London, where Gary and Dave, in their typical denim jackets and jeans, would greet him with handshakes and back-slapping and tell him they were on their way to a party nearby that he should come to, which was now going into its second day..

As they arrived, from across the street of the address, the place looked like one in a line of old store-fronts. But dodging the

traffic, coming right to left, to cross the street, he greeted some people arriving wearing top hats evening dress, and furs... It must have been an international group of people, as he could hear a man and a woman yakking in Spanish in the next room.

Inside, the place was actually someone's home, and friendly guests told him the party was just starting to get crowded again. But there was his Mother, being one of the hostesses, and he remembered she telling him she would be helping at the home of old friends of the family, and that he should come today and meet someone new -- a novel idea.

And there was Dayan in the second room standing by the buffet table.

After greeting him with her usual innocent cool, she tells him that she wants to sit down in another small sitting room. But his Mother injects "Please, put some wood into the fireplace..."

"---Just a minute, Mom," he responded.

He sat Dayan on the sofa, and himself across from her,

but by the sudden flush in her face

he knew something was wrong,

and he came to sit next to her (as she began to

inexplicably cry) and he took her hand to comfort her

not knowing what to do/ "I just want to help, Dayan,

please tell me what's wrong, what's happened.....you

should know by now how I feel......"

but tears poured from her amber eyes, (not for him)

and his coming words were lost in the moment

she breathed "why did you _stop_?" finding her tears and her wet cheeks pressed upon his own face and her lips to his.

END OF DELUGE

INFERNO PROLEPSIS

CHAPTER ONE

This is damned silly, he thought on the surface.

....the mind blurbed away the pathetic mulling – reflective images -- photos on the orange velvet insides of his eyelids.......

time gone, done.

with drab grey pushing through, focused beneath weighted lids -- each single wave rolling slowly over the beach,

now washing away the foot-prints.

-- pushing through Outer Optic Defenses,

through the retinal funnel.............

the wire mesh fence strained out the world of

suburban houses painted white with pink shutters,

he now remembered, venetian blinds inside windows,

gold-on-white patterned kitchen wall paper,

formica paneling, beige wall phone

 he'd talked on. talked to each vaporized friend.

and outside, the white hanging sky overcast --

viewed from between two white-shingled garage walls,

 voice radio

signal breaking through in crackling tones of pink den :

"........Open Channel D, please........Lock in grid

circuit to Dream-warp 27........"

 BLANK OUT -- into white sea, OMMM.......

(white nothingness, white whole sky vomit,

white/ gray/ white/ gray/ white........drab delusion..

p u r p l e vectors blasting into brain

---- twanging cello strings explode)

 Throughout: hypothalamic nausea.

 "just a few minutes more---"

168

CHAPTER TWO

 "We're ready tonight," the wavering,

 lost, sober voice, up from the depths.

Abrupt jell.

Small, dark, empty room. Four or five young people
sitting on the floor in a circle, around the stolen blueprint.
Et cetera.

 Running. Through pine grove, nocturnal
silver-brown rocks and erect grass blade shadows,
down into the entrance of the underground complex with
metal steps scratch/clanking beneath boots
......and down

 into brightly lit fluorescent corridor, walls
wearily sighing with the flow, through siblings
monkey-bars, climbing, teachers in pursuit

 "Don't hurt.." magnetic talons losing

hold topple oscillation body into maniac
ultra-red spotlights, whining sirens.

The literal teacher was dead ... Eventually he turned
and trailed after his glacier.

Esperanto:
 <<Mallargigi strio de
 desiri papera nagi tra.

 Shuttera de nedifinita
 punkto......koloro ci
 sanga de pinka al
 ruga-bruna. Stonego bariero
 tra cirkauajo pafkampo
 instantano konstrui naj detrui,
 lasi post ruinoj. Ce via une diskon.
 Ce via une diskon:
 Mallargigi strio de
 desiri papera --->>

CHAPTER THREE

Low-yield shells and neutron-radiation
had taken a sizable toll in the area, especially
the part of town that lay south of US Route 1.
Most buildings north still stood, but as little
more than hollowed halls.

GRAND-WAY DEPARTMENT STORE,
a single large shopping building. There were piles of crumpled
crates all around the loading dock entrance --- good for cover from
stray bullets.

The early morning sun not yet set.....glaring on the white-
washed side of the large building.

Kicking his way through the rubble --- an armed vigilante
was leaning by the MEAT & PRODUCE NIGHT DELIVERY
ENTRANCE

Hauberc reacted coolly to this interruption, telling the guy in
camouflage "I'm military, only trying to get home," (to see what's
there -- if there's anything left. But these bastards kept bugging him.

-- The vigilante group swarmed finally across the (acres wide parking lot) the asphalt plain.

 He journeyed upstream.

 Rain drops beginning to thump the dry earth
as he walked up the back walk of his family's house.
The back door ajar -- he pushed it in and walked into
the back hall, the notes were visible on the table-top
part of the stove ahead in the kitchen
......a heart in throat eternity of four or five steps to
the see if the world had ended.

pools before his eyes, stumbling through blindness
rooms, and out onto the screened terrace.
If only he'd come back sooner <u>she</u> wouldn't be gone
too now his sister gone too, no one/ nothing/ despair ---

if she had only stayed, only lived

 the threatening black sky, wind bouncing from silver-
green leaves to silver-green leaves turned back-outward
........falling to utter calm in attendance to utter calm...
falling to utter calm, rain drops a moment suspended
without gravity, carrying the expectation
of an approaching Deluge.

 Up and over the step, his feet were escaping a

thunderhead Fallout storm (perhaps no escape)....and back through the house rooms, bounding over stair-landing back into the kitchen --

-- but empty house noise of whimpering, and up down-speeding escalator, to exhausted summit, left into the eyes of the floral perfumed garden ...

PROLEPSIS FOUR

When he entered the subterranean fortress of the Underground, Hauberc is puzzled by a message that someone identifying himself as the visiting Subliminal Agent from Prolepsis was waiting to talk with him.

But sitting alone in the conference room, no one arrives, and after a long fruitless wait, he wonders if this contact's arrival had been pre-empted, displaced among the chaotic forces in disarray outside, or perhaps whether the agent had already come and gone, and the oddly worded note -- "Please meet be 4 you come, Prolepsis." Who was he?

At 5 o'clock, and beginning to feel haunted, he decided that he had waited long enough, and emerged into the open cavern to look for the one who had given him the note.

"Oh, I'm sorry, Mr. Prolepsis," the partisan tries to tell him. "Hauberc had to split before you could come --"

Why did this name bother him? It was a <u>word</u> which
also haunted him, the definition for the form of rhetoric in
which the counter-argument is pre-empted by the terms
advanced in the proposition...?

If they mistook Hauberc for Mr. Prolepsis, had they
not already mistaken the other as Hauberc, walking out?
There were already several agent-provocateurs, and doubles
of him on the loose, looking backward and forward --

Standing at the beginning of a deep corridor into the earth,
unfamiliar <u>passages</u> he would try to read, try as the words fell apart
and fell together again, never seeming to follow from one sentence in
to another, couplings of rail boxcars broken loose, so many Boxcars
in this Century leading into the darkness..
Through tunnel to spot of light.

Red emergency spotlights, the sound of them was crushing
his ears; the blaring sirens wailing up and down continually,
suddenly ceased, plunging the cave complex into a strangled
quietude.

Looking into Najia's bright
young eyes again, the light that they had rescued in him,
a red beam shining from the far ceiling of the complex
above her head, radiating the color

in each hair into spun gold..

"a beginning," is the thought he thinks of this,

his eyes swimming through hers.

Last, he has begun down the stairs into the Maze,

the maze of Life, the maze of the Mind . . . "I fear what

I've always wanted," say his thought words.

Animated forms (along the sides) without reference

of known form to any creature or object flowing

greens, deep greens, changings, an elastic screaming

cacophony of misplaced pattern-macrocosms ("larger than

life")...

. . . . the brightness of colors of a crumbling kaleidoscope /

pouring through the myriad senses

Red-Violents rush implode

in multiples, bitter fragrances, sweet, stickiness of

honey, golden cascade down angel-tied-ribbon waterfalls

...glowing purple. black. silver. /Reversed thunder/

image-negative photo sensation of drowning under

surface of the subconscious totality of conscious audio-

numbed town's telephone circuits:

jumbled simulated conversations, a gathering of verses,

a switchboard of plugs and wires, synapses and veins,

a maelstrom of words and phrases, voices running

together sucked into the maelstrom con-vortex

set against the video re-run tape: wildly swinging
vermillion cone rushing inward, smashed through the
last optic barrier...

Glacial chromium flowing, climbing through
tremendous
crests of lava --- the internal EMOTION CIRCUITS of the
Communications Reactor, overload (adjust the gain), --- the
volcano inside seething red-silver mercury tissues,
a torturous passive blaze, --- frantic
attempt to recapture the instant

(1/15 second on ASA 160 film):
multi(tangerine blue green yellow amethyst vermillion
bright chartreuse) -- color paper rings strewn
about thru edge of the mirror, the emerald
glistening internal-world clear molecule crystals ---
behind, drifting into un-focus balloons & haze
light photon spots of primary color, the basic building
blocks...

Low whistling of air which fizzes through
teeth and pursed lips, building unconscious resonance :

1) colliding shaded silhouettes behind the Corneal
screen

176

2) FORCE OF COGS. SALIVIC GEYSER
CRUMBLING THROUGH ORGANIC ANTI-MATTER.
OVER THE EVEN SOUND A SOFT- W H I R R R - R O A R OF
METALLIC HYPER FLOW.

Intensity Tuning increase audio gain control to bubbling
 Synthesis impinging sense totality.....red, scarlet,
 crimson through mouth, tongue, palate / raged tactile
 pungence into beauty
 slowly revolving descent aboard spiral
 staircase, number panorama (non-gravitate
 painted numerals on closed-circuit TV
 molecule screen)...
 slowly slowing(er) slow . . .

 . . .

 The helicopter slowly dropped down; watching the
landscape below : a neighborhood looming upwards,
rectangular patterns laid out, coming down into a narrow
 driveway or alley cutting between houses and garages;

dusky silver-green in the pre-dawn.

 Skulking through the mist, on the surface of the

 ground on guard-duty, quietly climbing over the waist-high

wire fence. 'Mom mustn't see me out here.' --- But he could feel her

saddening eyes, as she stood watching from behind the un-blown-

out window. He continued trudging along the edge of the small,

enclosed, sod-layered field./ A farmer's field. He dazed tiredly

lifted himself to climb back

 over the fence. The silent landscape patterns

 before him

 waited

Book Four

Zenith

"And I looked, and behold, a whirlwind came out of the north, a great cloud, and a fire unfolding itself, and a brightness was about it, and out of the midst thereof as the color of amber, out of the midst of the fire, there came four living creatures.

"And every one had four faces, and every one had four wings, and they sparkled like the color of burnished brass.

"Their appearance was like the burning coals of fire, and like the appearance of lamps: and the fire went up and down the living creatures; and out of the fire went lightning.

"And the living creatures ran and returned as the appearance of a flash of lightning.

I beheld, the appearance of the wheels and their work was like unto the color of a beryl; and their four had one likeness: and their appearance and their work was a wheel in the middle of a wheel.

"And they went, upon four sides, and their rings were full of eyes, round about them four. And when the living creatures were lifted up from the earth, the wheels were lifted up.

Whither soever the spirit was to go, thither was their spirit to go: for the spirit of the living creatures was in the wheels.

"And the likeness of the firmament, upon the heads of the living creatures, was as the color of the terrible crystal.

Ezekiel 1:4-22

"He woke up with Dark Information from the Dead. Wounded Galaxies tap on the window...."

The "Burroughsian Time Grid" song from The Fugs crossed his mind again...

Out far alone on the sand dunes of open beach at Lordship, Stratford, beyond the land bridge, looking out to a choppy sea..... Sky suddenly darkening rapidly to ominous, a large storm of wind and rain was approaching. A swirling invisible Tornado. Hauberc realized that he must run back across the landbridge or be stranded beyond the reach of shore.

Now he must cross the *bridge* back into Being.

If he is responsible for the cataclysm of the planet, the nuclear war of attrition. Destroying the Communications Reactor was the "trip-wire" to annihilation : How can he now turn back time and restore a safe, even if unresolved Reality ? Was Hauberc's "reality" a simulacra of the dimension of the Dream ?

Making it back into the sanctuary of his parked car, at first he felt safe,until heavy winds came ashore and buffeted the doors

and windows with pellets of sand and debris. "What an experience!"

Now he thought again about the term paper he had written in his 11th grade English Class, Mrs. Atkinson's class, on the subject of Existentialism – the *subject* of the predicate: comparing it to "experience." His point had started with the personal philosophy of Kirkegaard coming down after the debates of the Empiricists, the philosophers of experience of the early 1700s, and then the Rational Idealism of Kant. John Locke had first laid out the principles of a non-religious civil society, then, how to understand Human Experience. David Hume followed him with a *skepticism* of *everything but* individual experience. Then Bishop Berkeley advocated a personal *solipsism* -- only it was reserved for the leisure class: He tried to start a school on Bermuda to teach seminarians how to minister to the slaves and indentured servants of the colonial South, just to keep them in line. But that backfired: waiting for Parliament to grant him the funds, he walked "out of the room" too soon, leaving Nothing behind. They forgot *him* ! For Soren Kierkegaard, everything in the world was "a gift from God" -- except for his fiance'e's Regine Olsen's right to love him, so Soren dumped her !
Well, he thought now of how Karl Marx had exploited the dialectics of Hegel to continue the Class War after the Reign of Terror.

After the defeat of Napoleon, the European aristocracies had reestablished themselves, brought back the Inquisition, and brutally put down all the subsequent workers rebellions in the "Industrial

182

Revolution" every twenty years or so. Perhaps out of revenge, the Prussians had invaded France again and again: 1870, 1914, 1939.

The preference at the back of Hauberc's thinking in his introverted life up to then had been his thirst for *experience,* "Experience" ! -- Not combat, but travel, literature, art, and intrigues. His hunger for books and knowledge had left him hungry for *life*, the kind of life that vicarious experience couldn't convey. The paralyzing shyness of his early years had still held him back, until free-thinkers like Opal and Persephone had set him free.

But the importance now was "To be there." -- Heidegger left it up to the context of the sentence itself, the *tense* of the past, present, and the future. The Infinitive. H.G. Wells' time-traveler "George" demonstrating his miniature model of *The Time Machine,* to his invited skeptics pointed out that "Time" is the dimension coming out of the first three physical dimensions: it opens like a flower-blossom, or like a benign cyst, or else it opens as a geyser of inescapable billowing fire from the cauldron of the volcano.

The dragon of Time swims in the fire-boiling core, the heart of the planet Earth, the heart of the each Sun.

Sometimes we can spot the little Salamander basking in the middle of a camp-fire or among the flaming logs in the fire-place...

Both the Transcendentalists and the alchemists warned: Do *not* face the Dragon without a *thought*. The dragon is that which both impedes the progress of growth *and also that which spurs it*

forward. The static of nuclear worries Hauberc and everyone had lived with for decades had blocked the already subtle sound of the Earth's oscillating Harmonic Tone as it trailed through Space around the Sun. Kepler had mathematically calculated the sounds of each planet from his data. Hauberc had heard the real static hissing forth from his grandfather's wooden 1928 short-wave radio that he had had his father haul up from the basement for him. The oscillating signals reproduced themselves on double and quadruple frequencies, as did amateurs' uncalibrated transmissions, against FCC rules. To hear the real "Harmonics" without a radio, one must reach the psychological silence and then realize one's presence in one's location: the terms of responsibilities of each of one's life.

-- For the *Thought* to be a Positive mental image, a Positive Force, and a Positive Energy that will mold the Present in order to maintain the things and the sensibilities that will open the future as a bright flower, to feed it with Light, Warmth and the water of Love. To give respect to all points in the universe as equals. All things deserve to exist. The "I" of Hauberc is a star of light in a vast constellation, the "I" of his story-teller – the identical Point of Light. But beyond the Wall of Time, the border of Death, Hauberc and I together walk the dirt paths over the landscape of *Karma*, the never-ending sequence of actions, The *karma* of Contemplation, the *karma* of positive selfless Action, and the karma of love & forgiveness: theses are *all* EQUAL.

Period. ...Gita.

I will have been transported back to Earth from the Prolepsis Neb

ula, in order to assume John Hauberc's identity. The mission must proceed.

Being is... Non-Being is... Being and Non-Being Are. Who the hell said that ? Oh yeah, Parmenides. But next in the dialectic, Empedocles insisted that there were only two forces that formed the entire universe: Love against Strife.

I... I... I... I... I... I... I... I... I... I... I... Who?

I of Hauberc. I of Ruta. Looking into the fathoms of the Present. The Etruscan *Janus* as a Herm standing alongside the *route*, facing two opposite faces – looking back into the Future. Looking forward into the Past. As a principle of space/time, **Prolepsis** is the phenomenon of actions taking place in the future, which are expressed as already accomplished. Comparing the infinitive tense of *"is"* to the future-plus-perfect tense as that *"which will have been."* The projected future is the *just-now-accomplished.* The electron in the level of the blue orbital shell around the nucleus has jumped to the green orbital shell. Quarks firing at trillions of degrees, the network of Strings: The spark in the Death/Non-Being dimension which inaugurates our Singularity of Space/Time/Matter. Time's forward unfolding, *Time's Revers'ed Thunder.*

The Quantum Leap: Hauberc, the protective layer transmuting to become the *Root* of the Singularity.

185

*"Oh Mother **tell me more**! -- Why'd ya have to leave me there ?*
*-- hanging in my infant air, **waiting** ? You only have to read the lines*
*of scribbly black and **everything shines**....!"*

[Pink Floyd "Matilda Mother." Piper At the Gates of Dawn.]

Looking into the darkness, into the black overhead carpet, the sea of stars across the galaxy which surrounds us, each start sparkles like a colored jewel in the "night sky" above, from where *I* stand, like Odysseus, lost and longing, on the top deck of a ship moving across the wine-dark sea... ("The wine-dark *C* ?")

But in this moment, all that *I* have on my mind is the danger and importance of the discreet diplomatic mission to which Xerxes has assigned me, to make contact with the unknown race who have sent an envoy to speak to the Security Council. The conditions and the situation of which he speaks have no known factors to our world -- a dire warning of pending interstellar war between conflicting factions in our quadrant.

The Security Council is perplexed with the disbelief of his identity and the distrust of his sincerity, but I am perplexed even more deeply by the tragic fate of the old world we knew, and the emptiness of the new world that has survived -- the bravery required to forget

those we have lost. The devastation of cities and towns simply abandoned to be overgrown by new species of mutated vegetation, an overheated planet returned to jungle growth and shifting desert.

Even thoughts of Persephone or Najia had drifted off on the surface of the River of Lethe, the waters of which we are forced to drink -- to forget what we once took for granted and at the same time feared for annihilation. Past dreams were now overrun by new politics, new opportunities, and new missions : To try to evolve humanity he must travel to distant worlds, appointed to new responsibilities by the same men who had launched the world nearly back to the stone age only two years ago.

Our mission must travel the vast distances to the Prolepsis worlds, already spanning three planetary systems, aboard an alien star vessel placed under our command, an alliance unknown to the public, which, because of the still on-going war in Southeast Asia, lies already in a state of unrest.

After a mere fortnight at dizzying hyperspace velocity through the black ocean void of distant stars, the diplomatic ship enters a remote star system and approaches the first of three more worlds with which we have been assigned to initiate contact. The ship approaches from above thick layers of a cloudy gray atmosphere and fixes in an orbital attitude high above the surface. We transport down to explore a wintry, hilly planet.

Watched through snowy bare-branch undergrowth, as we seek the settlement our sensors have indicated, hoping to make contact,

we can find only wide paths through groves of black trees, soon finding ourselves atop a high rocky ridge, standing out on a wide cliff, overlooking cloudy tracts of terrain.....

But here we are suddenly surprised from behind by the tall, spear-wielding inhabitants who take us captive. When we hastily try to explain our mission, they gesture and point above, as though having seen the size of our great warship --

In the confusion of the bickering amongst themselves over what to do with their captives, two of us manage to dodge quickly away running off through the trees /

At a safe distance, I flip on my communicator to contact the ship waiting in orbit -- but the radio frequency grid circuit appears to be inoperative, so we are isolated, stranded.

We creep back toward the rocky ledge, to attempt to rescue our hostage fellow crewmen.

But when we are within earshot, I am appalled to hear the escape idea our fellows are murmuring amongst themselves in Pig-Latin talk, without comprehension by the unsuspecting captors
"Ush-pay em-thay over the iff-clay--"

The inhabitants, attempting to talk to them in broken English, call themselves Dropsies, unaware of the Earth language meaning, and keep our people at spear-point -- slowly backing them closer to the edge of the cliff.

But my communicator suddenly reactivates itself, loudly clicking electronic musical notes of the subspace grid circuit, revealing our position behind them(Inside the cigarette-case/ electric shaver size radio, miniaturized nano-Dropsies are climbing around in the

gears and clippers and flickering electronic chips, clutching hold of each tiny stubble of beard as it passes over my face . . .)

Audio squawks issue from the little radio and echo back through the cold dry air, quaking the entire forest with reverberations, rousing from their tree nests the other slope-dwellers: huge green-feathered birds that the inhabitants call Cabbageites, flapping themselves up the cliff-side, their claws outstretched and extended over us -- to savagely attack the Dropsies, and thus save us from them, but also thus thwarting our diplomatic mission.

We are brought to a stark area, an ecological wasteland of the planet : crude dwellings on a hilly alkaline landscape.

The inhabitants are the surviving remnants of a formerly thriving world, now destitute and starving. Our diplomatic ship, still in orbit, suddenly signals to us that it is under attack by a powerful battle cruiser.

We are left stranded, as a massive enemy ship approaches over head through the haze and clouds of hydrocarbons.

A landing party appears nearby, seven-foot tall lanky hairless creatures, likely the ruling species of the planet, recognizing us and taking us as their own captives to cells in their great citadel.

Some days later, left without food and only a filthy pipe of dripping water we can only pray is non-toxic to us, we are retrieved by new guards, who we recognize to be our own people. They bring us down to the desk of the alien Sergeant-of-the-Guard and coolly exchange papers for a transfer of prisoners, then nervously bring us out through streets and over a bridge away from town into a wooded

area, where we are brought aboard a large passenger space-cruiser of the Dropsies' commercial fleet.

In order to effect our escape from this planet, we must remain under the pretense that we are still the prisoners of our infiltrating comrades, and we are placed in individual, cramped, tiny locked compartments with curtains to be drawn between each.

After a long wait for take-off, an attractive female humanoid flight-attendant peeks in on me sympathetically, and tells me that we must first stop at a neutral planet before our destination of Earth.

We soon arrive at our first stop, but a humanoid reception party greets our ship, and they tell us that we must depart immediately before we infect them with our diseases. Yet I remain hidden as the people re-board the aircraft, so that I can evade being returned to my cell.

I dash through a bank of glass doors, through the great crowded terminal building, walking briskly up the up an escalator, but only fast enough that I might appear to be a traveler late for my flight rather than a running fugitive. But the express escalator abruptly halts its ascent some eighty feet above the floor below, and there is only a steel girder as my possible escape route, as I see Dropsie guards positioning themselves at the top and the bottom of the ramp.

I manage to shimmy across the opening to the end of the girder and dash up another stairway out of sight of my pursuing guards, and I am then out-doors.

As night falls, I am running from a hill street, down a murky bank into a pale gully, blue flashing lights starting up the hill behind me. With the sanctuary of dusk, I must find the houses where humanoid partisan friends live somewhere on this hill.

In the morning tomorrow, I search through the souk, through the purple light and warm effluvium of spices, deep into the twisting arcades of the crowded market-bazaar, until I find the little tailor shop with its tell-tale shop sign that reads:

"ALTERATIONS ALWAYS DONE ON TIME."

The proprietor from Earth, clad in a white burnoose and a maroon fez, quickly leads me through to a back doorway, out of his shop and into other corridors of allusion....

On the bridge of the starship, having escaped the Dropsie Planet, freely crossing the interstellar toward our home planetary system, Earth, we find our trajectory to have suddenly penetrated into a dark void of space: there are no stars visible --

We hastily request the navigator's sidereal analysis, relative to our last visible position, and he sets to work diligently, but then abruptly disappears from his station, the atoms of his body disintegrating from before his console as if seized away by some entity aware of our plight. No sooner have we witnessed this than the rest of us are also taken -- momentarily finding ourselves back in a darkened town of Earth.

I recognize the area where myself and the others from the starship have arrived, in a residential neighborhood of Stratford perhaps twelve blocks away from my own parent's house, down the hill of Allyndale and Wilcoxson Avenues, on the next short street parallel to the end with the name of Sunnyvale Terrace, also coming out at East Main Street, closer parallel to the river.

(Still, arriving so unexpectedly here, not in sunny daytime but ominous darkness, I flash back on my childhood memory of this area under water, when the 1956 hurricane caused the Housatonic to over-flow its banks, and to shallow flood the streets all the way up to my school-yard at Wilcoxson Elementary, as I stood looking from people's back yards on Stiles Street hill...Could the flooding have ever been that deep?)

On this street in the dark, tonight, we are drawn to a house nearby, under where a lone streetlight flickers, the only house with any lights still on inside curtained windows, as it seems far past midnight here. We approach the moonlit arched front door with a brick-laid front walk, then hesitate:

I ring the doorbell set beneath the tiny fisheye peephole -- a pull-cord ringer -- finding at the end of the short cord in my hand a tiny skeleton head..

With shadows first moving inside the peephole, the door slow-ly opens, answered by a strange young woman, in a long black dress with a scoop neck-line, under a black lambswool cardigan, flowing dark hair, pale ivory skin, inquisitive soft black eyes -- an attractive, demure, yet witch-like presence that greets us silently, bids us enter out of the chilled night. As she brings us inside and closes the door, her soft hand accidentally brushes the skin of my wrist..

There are dimly lighted rooms stacked with many bookcases, a carpeted staircase: the sense of quiet elegance drawing us in.

I remember our purpose, our search for our navigator, recall

landing on the surface, coming to this door with others from the bridge, but now there are no others when I turn to poll them their analysis of the situation. The young woman turns to me, her face silent, lovely and sensual, and the rooms spins:

She tells me of an art object she wishes to show to me, a small piece of sculpture. She leads me up the oriental carpeted staircase to show me a tall figurine which stands on an antique 'etager on the upper landing.The piece is undoubtably Mexican, Pre-Colombian, a weighty stone carving of a refined but terrified face, with heavily droopng eyelids, stub nose, and open-cone like mouth.

Intrigued by the characteristics of this object, my eyes follow down the cherub-like body form, breasts and legs, to the precisely defined vulva, as the young woman runs her fingers along the figurine, silently caressing its legs -- I am lulled into a hypnotic phrase which no words suit in my mind; growing acutely aware of the perfect poise of this young woman's magnetic presence next to me, especially as I notice her breathing to come to rise and fall in unison with mine; her nearness and subtle scent to stand closer, drawn in spite of my purpose, into an invoked, heated awkward moment, into the kiss of soft lips at the top of the stairs; into the being of the white of her dark eyes, into the dimly lit ornate bedroom, her black dress suddenly falling to the Persian carpet -- the studied perfection of her naked form: hands drawn to the lingering caressing of shoulders and elbows which then lock over my neck in an embrace of physical passion, as though pulled through the walls of moments with the slowing savor of time, sinking down to soft brocades of bed...

But the tempo of our movements gains speed too quickly and we are soon entering and racing down a turnpike: pictures inside of her pupils, as yellow diamond shaped highway road-signs passing faster and faster, fractions marking the last parts of a mile approaching the desired destination, her invocations and cries of pleasure, touching and being touched, approaching and surpassing a bursting ecstasy in the firestorm of heated blood :

-- 1/4 -- 1/8 -- 1/16 -- 1/32 -- 1/64 .. 0 .. 1/64 .. 1/32 .. 1/16

By early the next afternoon, alone, I have meandered up from the night-time streets below my former elementary school, coming to the small grocery store at Paradise Green; though I've walked by my parents' home twice I have not reached the state of mind to enter it, wondering in what stage of deconstruction I will find its interior...in what continuum of time, past or posterior.

Activity at the district of small stores bordering the Green looks like any afternoon I remember, pedestrians crossing streets, young women pushing baby strollers along the sidewalk.

Coming up the long snake of Wilcoxson Avenue in the mid-morning, after leaving the strange, enchanting young woman's house near the bottom end of the hill, I had become aware of how self-conscious I felt, a sudden realization of the feeling already in mind, paying attention only to the edges of the cement curb under foot, grey concrete under the light of the partly sunny, partly cloudy sky, yet tripping over a small rut ... It was as though the narrow band of grass growing between the curb and the sidewalk, and the distance to the corner at the traffic light (working again) at Main Street, were the width and length of the entire world, as though somehow anyone I wished to see could turn the corner up ahead and come this way, instead of coming around behind to come this way on the connecting side street from around the corner at the other end of the Green, staying just out of sight through the same cycle forever...

In the little grocery, my attention is drawn to some customers who have been milling around the aisles of shelves, and then go to address the grocer. I hear them ask directions to Reed Street, and watch them communicate in the common sign language of pointing this way and that, indicating the way north up Main Street which way to turn here and there; but they walk away looking more puzzled, while I have the impulse to give them instructions I would consider far more clear.

Standing nearby, I speak to them and attempt to advise them, but I am myself confused to remember whether the street is actually five or six blocks away, trying to count off the streets in my head by the landmarks I remember at each corner.... They smile and head out anyway.

Twenty minutes later, wandering up Main Street in the sunny after noon in the direction of Cutspring Road, I see the same people again, as they are going into the side door of a house on the corner where Highland Avenue comes down the hill to the traffic light. When they see me, they wave to me to come over and invite me in for a cup of coffee.

But their talkative friendliness is disrupted by their enthusiasm for the television: "Captain Video is coming on in one minute!" the husband exclaims, and they bring me into the living room where they sit me down on the wide sofa as they warm up the mahogany cabinet Emerson TV set. The black-and-white picture tunes in finally to a scene of a spaceship blastoff, and then the face of the pilot contorted with the intense G-force of escape velocity -- The spaceship soon is seen entering another cloudy atmosphere, and the television voice intones:

"Captain Video now arrives at the distant Prolepsis Nebula, in search of the lost explorers..."

But the space hero himself is soon engulfed in the thick veils of steam, as his ship veers lower to the surface of a planet, the image of a steam locomotive engine chugging down its railroad track spewing up clouds of blue steam and panning out into a scene on the black & white TV screen, of a red and blue lit sunset sky, the engine moving across the horizon beneath enormous grinning laughing faces...

prolepsis 37

On my way back through the Paradise Green area of stores and shops near six PM, still daylight, I come by the presently vacant super-market building on the corner of Wilcoxson Avenue and Main Street where three furtive and suspicious looking people come out of the long-unused night-delivery door.

Unnoticed by them, I curiously watch them reenter the building and disappear. Trying the door behind them, I find it open, so cautiously enter into a dimly lit hallway which leads me toward the rear of the building into a basement storage area, arriving at the rear

of what appears to be a large ritual chamber, peopled by the robed members of some kind of cult, gathered around an altar smoky with burning incense.

Fortunately, they are so immersed in their ritual they have not noticed me, so I hide in one of the authentic church pews they have installed, and observe as they prepare an animal sacrifice upon the altar. But my secrecy is short lived as another of them appears at the end of the pew with a pistol leveled at me, ordering me to come down to the front of the altar...

3 AM comes, and I have only come as far as two blocks down Wilcoxson Avenue from Paradise Green. Comrade Opal, my rescuer, is walking with me to bring me to my parents' house, where we will steal into my room and spend the rest of the night, hopefully neither followed by the cultists nor bothered by my father.

But when we come to the corner of Bell Terrace, a very short street between Wilcoxson Avenue and Allyndale Drive which over-looks a small field and Brewster's Pond to the east, we become aware of a mysterious dawn that is taking place very rapidly. We check our watches and determine that the sun is about to rise and make day *at least two hours ahead of its proper sidereal schedule*, a brightening blue then orange light coloring the sky, with a peculiar flash of green like a beacon light, the so-called "green flash," sweeping briefly from northeast to southeast and then over us, gently rippling into intense sun beams across the pond's still and misty waters...

Opal and I glance at one another's face, but with the green dawn light we are flashed in a transportation to a different location: a dusty village of ramshackle buildings and huts, the intense heat of an African afternoon, the black smoke of sporadic fires, an overturned jeep off the side of an old rutted paved road, punctuated rifle fire in the near distance towards the hills...

A tank rumbles down the wide road, moving east past where we hide by one of the houses, and confronts another kind of tank. Both fire their turret guns at once, the camouflage one that is coming to wards us exploding in a massive ball of flame, and the blue painted one with a shredded blue and white U.N. flag, continuing past it.

A moment later an open truck carrying some men and boys comes by following in the same direction. The people begin waving to us to come and get on.

We ride with them several miles along the flat paved road until we see a car parked by the roadside which Comrade Opal Arfano-vitch, indicates to me is waiting for her.

A short time later she and I are sitting in the large back seat of the old touring car heading east down a black-top two-lane highway across wide rolling hilly bush country...

A sign post reads <u>Nairobi 180 km</u>.

The man with the driver calls back to us, "We'll make the west coast by tomorrow morning, and be in Casablanca in twenty-four hours..."

"It can't be done," I challenge his logic. But Opalescent rolls her eyes at me, "By plane, you know."

"Biplane?" I repeat.

After we stop at a road side bodega for Fanta Lemon sodas and the use of the indoor bathrooms, noticing the lush touristy decor and carpeting of the place, though the language spoken is neither Arabic nor French. Eventually we are back on the road, seated comfortably in leather upholstery, where I later drift into dream.

(As the car passes on the highway, I am hiding in the marshy reeds off the opposite shoulder, my crocodile eyes coming up out of the murky water to watch the car swooping by me, just out of reach of my pointed jaw, and trying not to splash water onto the road so that they will not notice me behind them as their car climbs the other slope)...

In the more temperate sunny coast city of Casablanca, we walk along the sidewalk in the Western looking residential section of the old European Quarter where we are finally to have a meeting with Xerxes, whom I feel, by now, has avoided contact with me since assigning me to the diplomatic mission to Prolepsis. I can only think that he wishes to stay in deep cover, and not risk being seen as recognized or familiar with me. The unusual overcast day is beginning to fade into dimness; and Comrade Opalescent and I walk by house after house built of white stucco, arabesque portals, surrounded with hedges, palm trees, and iron gates, until we come by the one which I recognize. A plaque of gold lettering in three alphabets, Arabic, Cyrillic, and Roman which plainly reads "Counsulate Bulgarie."

Not sure how we should enter, I walk along the outside wall by the automobile driveway, looking into the windows where a party is no doubt in progress. Servants in the kitchen notice us looking in and gesture to Opalescent to bring her people around to the side door where they allow us to enter the gathering.

We pass slowly through garden terraces where many people sit and stand about holding glasses of wine and chatting in several languages, and through adjacent rooms where others sit amidst the scents of spices, liqueurs, patchouli perfumes, incense, and hashish. We also are bid to be seated amongst a multicolored gathering and are provided with sweet drinks, condiments, and hookah.

Inside later, we are seated in a small room adjoining a larger one where more people are seated in quiet conversation. Close by, I notice Xerxes sitting speaking in a rather arrogant attitude with some people whom neither Opalescent nor I recognize. For a single instant, he stares at me from across the room, with an almost imperceptible narrowing eye -- as though to warn me away from any sign of recognition which could betray his undercover activity.

But at the same moment, I seem to instinctively sense another presence, drawing my attention to a curtain which appears to cover a French door, but when I non-chalantly draw back the drapery find a small alcove with a small sofa upon which sits Najia.

"How did you come to be here?" I ask her, realizing I had last talked to her in America.

But she slowly shakes her head and smiles, inviting me to come inside, beside her on the sofa, and draw the curtain. Rather than giving explanation, nor questioning my arrival with Arfanovitch, she

201

hands me the stem of a water-pipe, and I do not question further, even of her provocative soft cotton dress.

She bids me only to listen, and between the noise outside the curtain I can hear that the combination of the sounds of the interposed conversations of the outer room blended with the strains of the Arabic music of the radio which produce, as Najia moves closer under my chin a peaceful and clearly musical fugue of the totality...

My next awareness is of rays of sunlight shining on my face, awakened to a stream of morning light, still on the same sofa in an alcove by French windows, though now alone.

Once fully conscious, I walk about the house, wondering after Najia, then out to the sidewalk where I can see two figures far down the sidewalk, walking away, and I recognize Najia with Xerxes.

I quicken my pace, but they soon disappear through other twisting narrow streets.

Future Tense Tense Past

Epic No. 1

Prologue in an ancient moment:
yellow pink den small room Venetian blinds
on windows
an old short-wave receiver atop maroon
leather bookcase
(a young boy in wonderment);
6L6 vacuum tubes sticking up naked
behind parched yellow dial.....
tuning in high-frequency bands,
emergency conditions, lost
searching for some signal
of Outside-ness remaining

(afraid the listening-detectors

will fix onto me)

moving into lower frequencies

"don't go into that band" "Alpha Alpha 1

Tango Sierra Victor....."

network of communications

all falling to emptiness

Fade into TV EPIC:

The Mountain (Paris, 2 June, 1793)

Scene: Enormous amphitheater political convention in park.

 Turning away from the proceedings, I look behind
across the field to the road where lines of cars are parked, to see car
thieves running from car to car down the line, checking locked doors,
passing my little egg-yolk yellow car. ---Suddenly, there is coming
up the main road an entire army of police cars --- But the police cars
at the back of the line appear to be large horse-drawn carts carrying
standing prisoners holding onto the rails of the carts on their way to
be guillotined, followed up by throngs of jeering citizens of the
Republic. .

At the distant road, the line of 20th century parked cars are vandalized by the throngs of the crowd, and then the car vandals are fired upon by the army, and begin to flee the scene -- They are summarily mowed down by the machine-gun fire…The Army of Police moves up the hill toward the amphitheater / Over blaring electric bull-horns Martial Law is declared to be in effect --- Heavily armed soldiers are now standing on street corners as people return to their homes.

I slowly realize that Najia's story about the choice between the disintegration of Time or the disintegration of Life is true, but the time may be already too late!

Next, on a ridge high above the Hudson River, on the grounds of a secret government communications laboratory, which they call the "Communications Reactor" I am part of a small group of guerilla fighters which I've been assigned to infiltrate by General Simone. Entering through a tree grove, I am carrying a monkey-wrench sized bolt-cutter. Moments later a sentry lies unconscious on the ground, and the wrench size thing lies in the tall-grass, where spot-lights shine, making strange green-black edged shadows on the ground.

I look out across the river with my binoculars and see a car riding down the highway on the opposite side --- they flash me the "go

sign." I move down a passage into the building on a narrow metal spiral-staircase, down through the dining hall then into the security area where the super-computer fills rooms with electronic circuits which maintain visual and audio surveillance by satellite and micro-wave on any person, place, or thing on the planet....

I am able to move inside the building and find the set of blue-prints that I have been told to retrieve, but then I realize that the "device" our group has brought has been detonated -- an explosive charge which quickly releases a corrosive chromosomal gas into the air -- immediately mutating everyone in the building.

I rush towards the escape hatch above to the field outside, but am suddenly rushed by guards who pull us back so that we topple towards the floor – Everyone seems familiar to my mind as the floors and ceilings warp in and out of place: I am in high-school again, chased by teachers who are discipline monitors, who are tackled and savagely beaten by unruly students in the hall-way and cafeteria...

The rest of History extends out before my senses like a train wreck of a million cars reaching out to the horizon into mists of fetid vapors rising from the wreckage...

I become aware that everything in this moment has become reduced in scope to a reduction of its true meaning, all sketchy memories of now, even as to how to describe what is happening to me -- all seems less than the reality of the events as they happen, all seem reversed in order --- that the unknown in the only thing conscious,

and the known has submerged below the level of awareness....

But at the same "time" I begin to realize that all forward movement of events has come to a complete stop – that Space and Time now grind to a halt --- and that my emotions and memories of it all are passing through something like a screen tea-sieve, dripping off into a Fifth Dimension of the Unknown. I must first discover and relive the cause of these effects before the universe can begin to move in any direction, before, forward, or to repeat itself, from this deteriorated mass of Matter through a state of pure Energy then into Light, everything must first be transformed......

I wonder if the vapor's transformation to my genes will affect my ability as..an..agent...before...I...can....escape....

EPIC No..2

-Phase in:

London ciy twilight, blue-red darkening, forming canyon
shadows between large old houses of streets across from a park-land
of shrouded trees towards the Embankment.

Four of us arrive at the outside tables of our favorite Chelsea
coffee-bar, Guys-and-Dolls, on the King's Road. Sitting with his chin
propped on the handle of his walking-stick at his usual table, is Marcel,
a burnt-out old vaudeville man, intruding into the conversation at the
next table, yet another pair of naive young female American tourists
with his standard line in his most horrendous scratchy voice, "'Ello,
luvs, which of you would you like to see the unique tool I 'ave in my
possession, wif which Oi uses to crack cokynuts wif...?"

Noticing that his walking cane has somehow been cracked
in half, I interject hoping to spare them, "Marcel, I see your pole's been
broken."

"I used t' crack wolnuts, but me eyesight's gone bad!"
Inside on a back-counter stool I'm reading the newspapers.

(Headline: BRAIN POLICE BEGIN ATTACK AGAINST
NOSE-PICKING.)

In an unconscious response to nasal irritation, I notice a bland-looking B.P. agent sitting on the next stool---Under-cover surveillance for partisan nose-picking ring.

I turn away, reach for my pen-size-communicator:

"Opium Channel D, please---"

Across King's Road we walk into a book shop, occupying the ground floor of stately Victorian era house across the street, but the elderly proprietor, a soft-spoken gentleman stops us at door, whispering a warning. "It's haunted here you know"-

We go in nonetheless, despite creaking noises from the empty house above, the muted sighs of strange old books....

The proprietor looks back at us seeming sheepish, furtive, and embarrassed, "Some days I just can't stand this presence of malevolence --"

Westin and I go walking up a street into the harbor district, through grimy streets, into a large hardware shop with tables full of many varieties of pistols, probably smuggled into the country. (I'm curiously looking to find a Walther P-38....but I handle many strange looking ones -- one with a small teardrop handle and a thin muzzle, another with a rectangle of metal saw blade/ with a divided jagged blade, the trigger beneath the handle, like a tin cap-gun---Testing it, I find it is a cap-pistol, so I replace it and pick up a simple black automatic with an anti-infrared detector and an viewing attachment for eye glasses.

We come back around to the haunted book shop, the

owner accompanies us up to the floor above the book shop. Standing by a dingy bare room wall we hear eerie creaks and moans from within ..

We begin hammering the wall with huge mallets and sledge hammers...(the bottom half of the wall finally crashes down---sound/ image falling, balsa-backed plaster spreads out its rubble onto the floor We discover a large chamber between the known inner wall and the outside wall---The owner stooping beneath the Dutch-door tumbled wall, dashes to throw open the large dusty window to release the captive ghosts... but one I see with my prismatic spectacles (as retinal-image ectoplasmic purple) flits across the room before us and up steep ladder-like steps.

(Dissolve: shock in and out of wakening)

Cut back into scene: dawn moments later; the ghost has been materialized by detection into its young female form. Someone tosses me another pistol, much bulkier than the first one---looks like a P-38 but it has a name engraved (raised black-gunmetal letters) on its side...I see the first letters "PH" of the makers label and think "PHONOBAR" -- the Amsterdam nightclub -?- But it says---PHILIPS (made by the Dutch electronics company)

Cut back---I'm holding the gun poised on the materialized girl-ghost; we're all sitting by the window in the discovered room. But she refuses to believe the gun is real ---so I shoot the floor before her ("-Hmmf-"), frightening the others, but convincing her.

During this commotion she manages to jump up and grabs a chair into which she integrates herself as jumping out the window into black time lapse --

Reading report later: ".......so I managed to escape by putting myself into a chair that I was able to touch in the confusion. But it smashed on the sidewalk before I could get out of it, and now I'm bits of the pavement, fuck-it".......

END OF EPIC No. 2

Epic No. 3

Purgatorio

Five years after my family had moved from the Village at Yellow Mill in Bridgeport, it was now 1954, and I was 7. On an occasional Sunday morning my parents would still meet their friends Anna and Paul Miasga in the old neighborhood, to attend Mass and then go out for breakfast together. We came to the beautiful cathedral-sized Church of Saint Cyril, located next to the village, near the long black stone railroad viaduct. My sister Juno, three years younger, and I had grown up together with the Miasga's two daughters, Catherine and Sharon. I was only the second oldest of us kids, but we were all always happy whenever our folks got together. Our moms had met while working as riveters at the factory where they made fighter plan es for the War Effort, while our dads were away fighting the war in Europe.

On this particular Sunday morning at the end of September, we arrive before the start of Mass, and Ann says to my Mom, "This is the High Mass hour, and the kids won't last through it, so we better

send them to Sunday School ..."

My Mom replies, "If we're going to come here often we'd better get them started, now's the time! It's September..."

So all of us kids are suddenly informed that Sunday School classes have begun for the year, and we all had to go -- So off the four of us go, all together, to each find our own grade classroom in the Parochial school building behind the big Church.

"You kiddies will have to go *all year*--" says Paul with his snide chuckle.

After Catherine and I have found the Nursery school room and dropped off both of our younger sisters together, she drops me off too, because she is one year ahead of me, "Here's your class room!" So I am now deposited alone, having to walk into the back door of an unknown classroom crowded with desks -- a sea of strange faces, my own age.

"Hi-ee," sings the penguin-like figure at me, a middle-aged nun who comes to the back of the room to accept me into her group, already in session. "I'm Sister Elizabeth. What's *your* name? " But when I tell her my name I notice a slight frown in the angle of her eyebrow, possibly showing her disapproval.

"And... how come you're *late*?"

While I listen attentively to Sister's little stories about how good boys and girls will go to heaven, and bad boys or gilrls won't get in and have to go to the "Other Place" where nobody wants to be,

213

I look around and wish I could become friends with some of these kids -- But I still hope we don't have to come here every week... Then Sister tells us that at the end of class we will each be given a little present as a welcoming gift.

After more stories about good lambs and bad angels who have bodies black with soot, the end of the class comes, and we all know it is time for us to return to the church where our parents are waiting for us.

But first it's time for our gifts "Now come line up in front of the table, children..." and we are mustered into two lines in front of a wide table set up at the back of the classroom, where stand three more kind looking nuns.

"All right, children, when you come to the table, you will each be allowed to take one of the little gifts that we've brought for you today..."

When I come closer to the table I see that each of my classmates is being given his choice and is then lining up on the other side of the door, waiting to be dismissed.

When I finally reach the table, Sister Elizabeth, joined by the others, tells me that I can choose between a Tootsie Roll candy and a string of Rosary Beads contained in a little frosted plastic box. This sounds OK, but when I see that there are only a few of the little boxes left, and allot of the candy left, I remember that I already have a nice set of Rosary Beads at home, which my Mother had reminded me to bring today, so I guess I might just as well take the candy, and save the beads for the next boy or girl who hasn't any, and they won't run out of those.

When we are all lined up to be dismissed, Sister Elizabeth and the other nuns seem to be making careful notes of our selections, and I notice that all the other kids I can see have chosen the beads. I'm glad that now everyone will have beads for the next class, and I'll bring mine next time, too.

Out in the hallway, I find Cathy and Sharon and my sister Juno waiting for me, and we go happily back to the beautiful church where we will be soon reunited with our parents, who are still inside, standing and chatting in the rear aisle, as the Mass has just ended.

All back together again, my Mom immediately becomes curious: "Where did you get the candy?" "The nuns said we could choose candy or Rosary Beads..." Then I see Mom's face go totally pale, and she trills, "*What ??!!* Oh, no.*"

Without even a reprimand or further ado, she immediately marches me back to my Sunday School classroom, where the nuns are still talking, and Mom says to me "Now, you ask them to please change the gift of candy for the set of Rosary Beads...."

They make the switch quietly for me, but their heads still nod skeptically, stroking their sparsely hairy chins, and whispering to each other behind their hands...

Eastern Sky : Paradiso

Come near, ye nations, to hear; and hearken ye people;
let the earth hear, and all things that come forth of it.

For the indignation of the Lord is upon nations,
and his fury upon all their armies: he hath utterly destroyed
them, he hath delivered them unto the slaughter.

Their slain also shall be cast out, and their stink
shall come up out of their carcases, and the mountains
shall be melted with their blood.

Isaiah 34:1-3

Many-limbed Hindu Siva, the balance of lightning poised
The face in the inner window, hidden;
The Oldest of Living Gods threw down his thunderbolt
At the world overwhelmed with water and fire,
And patiently awaits a continent.....

prolepsis 38

Driving to my hometown along the shore route, two weeks
later, by myself in the car, I finally have some quiet time to reflect;
and now the idea comes to me that everything that I've thought I've
witnessed has been the result of a single decision that I made to par-
ticipate in General Simone's scenario, before I knew all of the facts:
Everything that I've perceived has somehow turned out to contain
only half of the whole story in each situation. My logic of deductions
like the model of the part which is only given to represent the whole
of the puzzle, has only served to reduce my overall recognition of the
true whole picture.

Perhaps the only way to put the whole of the jigsaw diagram
into a comprehensible pattern was to assemble each segment a piece
at a time, where the forms fit together flush, like the bodies of lovers
embracing naked in sleep beneath the covers, like the adjacent shared

borders of neighboring friendly countries, with an artificial line to separate their bodies, or the continents against the seas of the earth, under the covers of rain clouds moving constantly above, to and fro.

The borders of East and West were man-made contrivances, only differing in their intrinsic open or closed fields of property, like the fields through which I've roamed in the memories of my life since first returning to consciousness.

But at this moment, I am becoming somewhat puzzled by the unfamiliar road I have taken, which goes on through thick woods northward away from the beach as though to circle around a cove, but then narrowing and flattening, and coming out close along in a westerly direction where the shore is somehow now on my right...

Though I do not recognize the area which I should know, I suddenly remember (or rather, the memory seems to flash before me) a recent premonition I have had of the presence of alien invaders which I would hear of while at the beach.....

When the road finally comes to where I can see the beach through the trees, I pull the car over and go walking over the rocks close along the water--- Some distance down the narrow beach, I finally realize the strange incongruity I had overlooked in my sense of being lost: that from here the sea stretches to the north and west, the opposite of where it should be on this coastline...

Continuing in the car toward the afternoon sun, further along the side of the expanse of water, swelling with incoming tide, I am surprised to see a small group of young people deep in the evergreen woods on my left, so I make my way through the underbrush

to get close enough to see them clearly without being detected ---
They are apparently hunting, stalking some small animal, chasing it
back and forth between them --- But there is something frantic and
giddy about their chase, as though they were themselves wild ani-
mals, dressed in clothes torn and oversized. But when they finally
see me, they become even more excited and together come running
over to me where I stand.

"Hi, Hi, where are you from ?" they speak in a peculiar
broken English, and with the tone of small children ask me, "What's
your name ?"

But when I tell them my name, they seem to think I'm telling
them where I'm from, saying "So are we! We're from Ruta too!"

I tell them that I am walking down the shore to see where I
am, and they anxiously tag along a few feet behind me, still smiling,
tripping, and giggling... I lead on for what must be close to two
miles, walking and climbing southward over rocky and sandy areas
of the beach, with the children splashing their feet in the water, until
we finally come into view of a long steel suspension bridge, another
few miles down the coast, spanning a wide and long lagoon, connec-
ting to a perpendicular jut of land with tall green hills---

"Where does that bridge go?" I turn to ask my young
companions.

"Oh, we don't know," answers the oldest one. "---That's from
the After-Time : you can't really walk on it :"

"What?"

"No one ever comes back from there..."

219

"Can we start back now?" whines the younger fellow. So we begin to walk in the direction from where we came, watching the incoming waves, coming to parts of the path which are now covered with tidal overwash : Crossing by the connecting stones to try to keep my shoes dry, while they simply slush through it in raggedy shoes, I for some reason become curious about the water itself, reaching down to touch it and taste my fingers to confirm its ocean salt...

Scanning the horizon, I suddenly spot what looks like a campfire in the woods on the opposite jut of land.

"Hey, I'm still hungry!" calls the girl.

"Me too," replies another. "Let's go catch an animal!"

Before I can say anything, they are all scampering away, shouting to each other all the way into the woods, and leaving me by myself, still not knowing where I am, so I decide to go back and in-vestigate the suspension bridge.

Crossing the bridge later, I discover it to be mysteriously in good repair, paved with new-looking asphalt and wide enough for a motorcar despite its having no connecting feeder roads at either end, or even a trail. On the opposite side, it leads me immediately into the woods over the crest of the opposite hill, heading in the direction where I had seen the small fire.

Downhill, I do come across a trail that seems to head toward the end of the point of land, and I finally spy the fire deep in thick woods--- As I approach, an old man sitting before a campfire looks up to see me coming and registers an expression of some sur-prise.

"I haven't any more candy, son," he calls at me as I come nearer.

"What about some coffee then," I retort, seeing his old pot hanging over the fire.

"Well now, where did you come from?" he returns, pouring me a cup.

"From across the bridge, but I'm not too sure where that is either... Why aren't there any roads to the bridge ?"

"No one's been across that bridge since the After-Time."

"When was that? What do you mean?"

"Either you have been living under the volcano, or you must be from another planet, to ask a question like that..."

"Perhaps another time," I reply.

"Time Traveling? Well, you're not the first curious one I've met ... This is the year 495 B.A. – What's yours? "

"Before something..?"

"Before After.... You see, we know the exact time when our land will break apart into the sea."

"Well," I reply, "I've always had a problem with people like Plato who lived their years in reverse -- 427 to 347 B.C."

"Were they expecting something as well?"

"Maybe the Utopian Republic."

"Oh yes, travelers mention his name. -- Well, don't wait here -- People on this side of the bridge are afraid of the police patrols from Phrengal."

"What's Phrengal ?"

"You had best be careful---Phrengal is only fifty leagues from here--- The police never bother me, but younger ones taken there never return to their families. Don't you know about that?"

"Can you show me where they disappear?"

"No, no."

"I've got to find my way back -- I think my family is there."

"You really want to take the risk?" he replies. "You don't know this land, do you?"

"Yes, despite the risk."

"Alright, before the sun comes up I'll walk down with you: but we've got to be out of there before the early patrol---"

Well before dawn, my companion wakes me and leads me through the brush and onto a trail heading in a direction that eventually brings us out along the north shore of the bay inland of the bridge. The sky is barely a dim green, when we reach the spot where the people were last seen.

We perceive sudden flashes of light coming from out across the water.

"This is where friends of mine vanished," he warns me.

Puzzled by the flashes, which come from the far northeastern end of the widening of the bay, we continue down the trail, and, coming alongside a wall of granite, we are suddenly surrounded by black leather-uniformed policemen appearing as if from nowhere.

My older friend glances to me with a look of pure terror, as we are motioned to climb aboard their vehicle, which resembles a

sort of flat-bottomed cabin-cruiser, with the aft-end built like a fire engine.

The police-"boat" proceeds to move off from the shore, with several others, barely children, standing on the running-board, as we are doing, strung together with one long chain and each holding onto the surrounding metal bar--- My older friend stares across at me bitterly.

A half-mile further up the shoreline the boat comes to land again, and the hydraulic crane on the foredeck swings around to hoist onboard a modern, silver-painted compact car which the patrol has spotted on a narrow road at the edge of the water, placing the auto atop the flat-bed even with our eyes..

But this time as we move into deeper seas, the added weight of the automobile cargo has displaced so much water that now the draft of the vessel below our feet is scarcely three inches to the water line. Realizing this, the pilot opens the engine throttle to full, the craft gaining more and more speed until suddenly leaving the water to become airborne...

As we attain greater altitude, with those of us holding onto the bar for dear life, trying not to look down at the clear blue sea further and further beneath us; but once our flight levels off, I realize that the view is unobstructed and truly spectacular: the dome above cloudless but for high wisps of ice, jagged coastline and green wood-ed hills below--- ...Eventually, as we move to the north and south, we come into sight of a peculiar group of tall buildings on the coast...

Our boat descends and comes to land atop a high structure over-looking an oval stadium. We are led by the police down into the

building, through a hallway toward the stair flights which will take us down into the city itself, but I become curious of the contents of the wooden paneled closets along the side of the wall, and brushing one open see inside racks of deep-sea diving suits made of heavy canvas and spherical iron helmets with glass faces...

And in the areas below, we come to enormous lobbies crowded with hundreds of people dressed in elegant toga robes. We are brought up in queues to a wide table where we are each given a large handful of gold coins, and we quickly realize that our guards have allowed us to circulate in the room, only standing to prevent us from going back to the roof.

Navigating myself through an area of cafe tables toward a wide opening over-looking the inside of a stadium, I can see chariot racing within and hundreds of cheering spectators... Where we stand seems to be the interior of a vast casino, with arrays of gaming tables, a vast buffet of lavish foods, and garden-like lofts here innumerable empty beds are visible, some attended by winsome-looking nude young men and women.

But my strange clothes have caught the attention of those sitting at the tables, and as I pass by them again they seem to haughtily scrutinize my every movement... But before my knowledge of their history to be, their wall of arrogance dissolves into a kaleidoscope of karma -- an unbeknownst pregnancy of total perdition...

I ride down the elevator, realizing why their arrest methods are so lax, that I have been left alone: that their natures could be so corrupt as to believe that these casino games will tempt new prisoners to accustom and integrate ourselves to their glamour and

extravagance. Where else is there to go but return to the uncivilized wilderness.

But I am unimpressed by it all, and want only to find the passage to the stadium and perhaps back to the sea, the doors slide apart to a long empty split-level corridor, bathed in the sunlight shining in through the end glass entry

Temple of Atlantis, submerged in turquoise shallows of Time...

Undulating watery veil, crystaline images:
Off Bimini Bahama a sunken wall along the sea floor, stone after stone laid at perfect right angles.....

A dream washes us from underwater, back through living realms of hopeless hell on earth, a network: straight lines of piercing ruby lights, beacons over turbulent ocean, faces and figures: dragons of the depths.

Coming through a brightly lit basement passage into an abandoned underground complex -- inland along the coast of the Island of Ruta...

A group of young people are moving several television cameras around and constructing a set with the feeling of a stark drama, adjusting the components of their equipment with the lighting apparatus.

I suddenly recognize Comrade Opal Arfanovitch talking to a man I also recognize as my former high-school teacher, Mr. Ted Maynard, who is apparently here in charge of the studio operation.

In the guise of a reporter with notebook in hand, she is asking him technical questions, giving me the opportunity to quietly approach, moving closer from behind the equipment, hoping the situation will be too awkward for her to rush off ...

"It was difficult for us to understand what we were finding when we discovered the war programs still reading out on the display screens," I overhear him saying. There was no one here when we broke inside. The war machine didn't require any humans to continue itself. But we think that a shorter Game job procedure was initially run to determine if there was an inevitability point-of-no-return. All the battle contingencies which have been run so far have the same trip-wire: when the Communications Reactor was sabotaged all radio bands were automatically jammed with white noise --"

Mr. Maynard begins to characteristically roll his eyes, but

lets them come to rest looking into Opal's eyes and then into mine in a serious look which somehow begins to penetrate into the meaning of time and the gravity of all the events that have followed from one single action.

He goes on speaking, as though time itself were seamless and absurd rather than torn in its fabric: "We're now broadcasting a live adaptation of Samuel Beckett's play *Endgame* over the NORAD communications satellite for a wide area TV reception, hoping to reach other partisans and people in hiding, and convince them that we have interrupted the war cycle... World War Four was running, and World Wars Five and Six were already set to be executed on predetermined contingency. No humans required. At the same time we've determined the breakpoints and are linking the play into the program cycle.. Maybe we can effect the outcome...

"The only problem so far is that our signal monitors outside the area aren't picking up anything on the airwaves at all but low-modulation static, and we know we're putting out a full capacity signal."

As I finally insinuate myself into their conversation, Opal continues the discussion by chatting with me, but I cannot gather if she recognizes me from our previous times of friendship, distant encounters, or if she has some other intent. But as we are just walking out through the hatchway into the night darkness, we see the monitor screen suddenly come alive with a series of peculiar and fantastic images: like rapid news-reel footage of ancient and modern wars, intensely colored flashes of a nuclear consummation, vapors of feather-pinnacled cities...

prolepsis 40

Riding along a road through a semi-rural industrial area looking for a certain abandoned factory where we hope to find needed electronic parts, Comrade Opalescent and I are in a car with two of the studio "boys" who had picked us up when we were hitchhiking back. She is again telling me about her painting process, "I've got to get back to my artwork before I go crazy."

When we round a corner junction of roads on a wide flatland area --- they stop the car and Opal rolls down her window to ask someone on the side-walk for directions.

..Later we've found the factory, but entering, with the two others following idly, we discover that the inside has been converted into a film-studio containing foam-plastic mountains used for artificial background effects, and we playfully begin climbing around the sides of one..

Where there's space at the summit for all four of us, I arrive last to the top, to sit on the edge...but I soon find myself off-balance tumbling down the miniature slope, grabbing through thick

fur-skin draperies until I slide to the floor...find myself in an enclosed diorama between lines of cottages on both sides.....

I throw a thick rope and catch it around the large limb of an artificial oak tree and try to climb back up the mountain... Looking up at the others sitting on the sun-gleaming summit set against a bright aquamarine... one begins shouting at me, but I cannot hear.

Later in the afternoon, Comrade Opalescent, anxious to get back to her art-work, has suddenly asked me if I would agree to pose as a life-model for her painting, and I languish nude in her attic walk-up studio (with wide window panels open to the bright blue sky and overlooking the architecture of a city interspersed with spaces of lush green, trees, and shrubbery, while she does two preliminary sketches, one in pencil, the second in charcoal.

Piled along the side of the room are a number of her earlier paintings, which, during a ten minute break in my pose, draped with a blanket toga, I pick through them, until I come to a dark abstract portrait of a young woman's mysterious face which I seem to recognize, drawn with one red edged eye and one green edged turned inward, waves of light brown hair surrounded by strokes of broken

visualized thought-forms, green and white, and the shade of the body a black sweater or a dark ghost.

"If you know who that is --"

"It's Dayan, isn't it? When did you paint this? Where is she?"

"-- I'm supposed to give it to you as a present."

"Where is she?" Opalescent shrugs and merely shakes her head. "I painted it six months ago. She commissioned it and paid me, then told me what she wanted to do...Put it over by the door, and get back to your position."

Rather than drawing in pencil or charcoal, Opalescent now goes to work with oil pigments on primed canvas, her easel across from the huge ornate pillows on which I am sitting awkwardly naked on the beaten up hardwood wood floor --

Out of the expensively tailored woolen business suit in which I had found her conducting the interview, she is now wearing a baggy turquoise and crimson jersey spattered with drips of oil paints, her well shaped legs bare in the warmth of the studio room.

As she becomes absorbed in her work, I gradually come to think, however, that she is wearing nothing else underneath the jersey, and I quickly realize that to control my own appearance is becoming more of a challenge, as I watch the curve of her sides, detecting glimpses of tufts of her dark hair, as she rapidly applies her paint in bold strokes of color.

I am impressed by her refined technique and abilities as a painter; she is surely a fine artist; but she eventually puts down her

brushes and comes close to me, deliberately, so that I will kiss and hug her with my usual friendly affection. But beyond the usual way, she doesn't move to part but nearly tumbles onto me so that I continue to kiss her, cheeks, neck, and shoulders, and so that I soon raise up her jersey to reveal the bronze skin of her midriff and round breasts... I am also puzzled and devastated to see that there seem to be some kind of cybernetic bolts, with smoothed over heads on the surface of her skin, on each side of the front of her smooth hips, holding the fuselage of her torso together..............

prolepsis 41

Ruins on outskirts of (obscure distant hills outside) Tangiers--- we climb down the small quarry --- an aperture leading down into catacombs.....

Comrade Opalescent has discovered a small box and brings it out into the sunlight; she removes the lid and spills the contents out onto the sand in a line..../

She spills out what at first look like jewels of colored precious stones, but I then see are in the shape of many kinds of cipher characters :

231

Clay tablet fragments inscribed with cuneiform/ translate ancient words and contiguous phrases whose meanings explode in visual images of history, Time-Currents of human migration in the Caucasus before the Great Ice; the arrival in the Euphrates delta of the Sumeri in their ships from the east bringing magic numbers -- These were the turbulences of moving paths of action and life through these hours, these very moments ... into the many coming Waves of the vast eternal sea, flowing through silhouettes of our reclined bodily forms ---Slow-motion the now "Time" of my (yourselves).

Comrade Opalescent, no longer standing away, is kneeling over me, painting in whispers the pebbles' secrets of splintered epochs: we begin deciphering....

Riding over the maze of local super highways, back and forth, for all the afternoon into the time of dusk, through wide coverleaf-circles, we arrive at the end of the highway, at the base of a billboard video-screen.

Walking around it to investigate, the screen comes to life... showing the view of a twilit alien or future city -- a tight network of feather-pinnacle towers, softly piercing the fair blue sky, blending with the surrounding green earth, and circled with gleaming

monorail cars whisking and winding their commuters through poly-morphic architectural forms...

(Returning recognition to me of a long-forgotten past from distant-future city upon a vast empty plain......)

The sleeper is anywhere across the cosmos, the music-dream entering softly the ancient portals...Pores of the skin...focused through crystaline mesh, volcanoes of fire cylinder wave-sound of blurbing image stream...Trans-dispersion into physical time direct-ions, radiating spokes of penetrating warmth into the distant circles of the astral Plane of Visions, now/here where live all the mystic others of eternal time, past and yet to be...

Awaken. Realms beyond contact--- (word-image-symbol metamorphosis.)

Nebular glow of dawn, planet of the ultraviolet gaseous cloud... The city of network feather-pinnacled towers. The Earthman is speaking: "Memory will soon be returning of past sequences."

Just returned to the US, I am walking down a suburban lane on a warm weekday afternoon, where Juno and her new husband George now are living,at the bottom of Wilcoxson Street Hill on a little road branching from the crossing-guard corner of the elementary school of my youth, just blocks from my parents' place. I notice with some surprise that the neighborhood has indeed become technologically upscale for there is now a large color television screen suspended from the arm of each telephone utility pole all the way down the street, all tuned to the same old rerun Superman program--- blue-suited, red-caped figure bounding into flight out of every tree down the line.

Juno, expecting her first child, and just beginning to show, invites me to have tea with her at an elegant little table set out on an open second-floor balcony porch on the same level with the mosaic of Superman shows on each utility pole... She and her husband George had just purchased this house, and I had helped with their moving, a few days before I was sent off to Europe on my assignments.

"Isn't this place a real find?"

"It's really pleasant," I admit, enjoying the warmth of the spot and the green of all the surrounding trees.

"I like it here," she explains, "because when the kids come out of school, across the street, they'll be under constant surveillance,

to keep away the drug-dealers and child-molesters." She points to the television screens. "Two-way monitors. We can tune in on Channel 1"

"Great."

Later, she has to go out, and offers to let me have a nap while she is gone in order to remedy some of my jet lag, as it is the middle of the day and I appear drowsy.

A while after she leaves, I determine that it is time for me to check the hiding place where I have deposited the whole set of instructions and blueprints from General Simone, which I have left here for safekeeping, inside a rarely used sub-cellar door, and I go downstairs through the basement rooms.

As I attempt to open the creaky sub-cellar door, I muse over the fears which I felt as a small child about the innards of the two sub-cellars of our parents' old house not far up the hill from here, and the fantasy that I had during the tunnel burrowing days of my childhood, that I would one day discover the tunnel leading from the sub-cellar of my folk's house all the way to Paradise Green, about a half mile west under residential streets and the brook through the park. This was the tunnel that Weston had used to get undetected to my house, and I remembered hearing from some of the D.A.R. ladies in town, that there were many more of these, scattered around, that had been dug as part of the "Underground Railway" by Abolitionists, before Lincoln's Emancipation Proclamation, a hundred years ago. When I pull back the small insulated door I think that I perceive a flash of faint reddish light, but disregard the impression with the logical thought that the light had surely come from behind me from

an afterimage within my own eyes.

But then I am puzzled that I am unable to easily reach the packet of documents where I first thought that I had placed them inside the wall. I shine my penlight into the space, and am suddenly upset to realize that there is nothing of mine there.

I decide to find another flashlight and to climb inside the space to check it thoroughly, so I soon find myself pushing aside cobwebs and masses of dust, with little or no light coming in from the small sub-cellar door; and I suddenly fall sideways about ten feet on an angle deeper into the darkness, as into a section I hadn't known that existed.

I am fortunately not hurt but for a scrape on my elbow and a sore back end where I have landed, but the flashlight, lying on the dirt floor, shines into an unknown passageway leading to the right, further into the darkness. I remember that it is essential to my survival that I find these papers, so I continue to explore.

I am more than surprised that the passage turns into something more of a subterranean corridor, and I am soon able to stand upright, and soon find myself walking on a tiled floor. My sense of direction tells me that I am most likely walking to the west, and on an incline as though uphill beneath the earth. Again I seem to detect a kind of faint red flicker in the darkness of the tunnel ahead of me, and I follow along in curiosity, until I reach a stairwell with steps which go in directions to both higher and lower levels.

Now I hear the foot-steps of boots coming down the stairs, and I feel a charge of fear throughout my entire body, like a powerful static electric shock, leaving me feeling stunned.

And suddenly, I can see the flicker of red light focus into the constant images of two small men bathed in red light, or even composed of bright red light, as though their bodies have become visible as I have passed through a metabolic time deceleration.

"Halt, intruder!"

The two creatures of red light identify themselves as Security Constables, and begin to question me as though I were a burglary suspect, telling me that they are on the lookout for the parties who have taken important documents from their government offices.

"But I am searching for strategic plans and documents which I stored for myself, and that's why I entered the underground tunnel!"

They escort me up the staircase and out into the daylight of the street which comes out from a normal-looking office door-way in to the middle of the Main Street at Paradise Green.

But I immediately realize that something is amiss, because the traffic of cars on Main Street, and the people who are walking on the sidewalk, all are moving at a dead snail's pace, that is, literally nearly stopped dead in time; a totally uncanny realization.

The "Security Constables" escort me, in this decelerated time, into a large building, unknown to me, which seems to exist only in this accelerated world. But noting that they appear to be weaponless, I decide to suddenly break away from them and manage to escape, furtively climbing the stairway of the building I have just exited, up three flights of steps to where I can hide behind a door as group of orange accelerated people walk through on their way down the stairs.

I go down the shady street (under a crawling, peaceful sunshine breeze), looking for the burglar, down stone steps, cross field by pond. But half way across, three people of blinding orange light appear behind me and in front of me ---

But as they close in on me to apprehend me, I feel another wave of electricity through my body, and they all begin to disintegrate rapidly into a single high-pitched buzzing noise, like the squeal of june-bugs on a summer day.

I also have vanished from them, thinking I am leaving a snail-speed, immovably weighted suspect for them to try to arrest while I arrive in a suddenly empty, detective-free space---

But instead my body fades through orange light and into the seat of a speeding first-class railroad car, with Najia next to me. I look down at myself -- and realize that I am wearing green pyjamas.

"We have to get there before it happens again," she tells me. "We must get there before the hours run into dusk."

She sits silently, stretches back her body in the comfortable seat, with her knees folded upwards, languidly resting.

I am afraid to ask her why she shows up in the most unexpected places, since meeting through her father Woloja. I begin to wonder if I really did remember her from the Communications Reactor.

"How did you wind up in Casablanca?" I finally put the question.

"Everything comes to a stop in Time," she replies, sitting up and embracing her knees seductively. "I don't remember anything

that happened in Contrablanca, except being very high. All I remember is what's just happened in the next few minutes," now tucking her legs deeper under mine.

"Are you being evasive or just naturally prophetic?"

"Pregnant..." She glances into my face and smiles.

"Rhetorically or figuratively?"

"It's already happened -- you must try to understand that I'm living my life in reverse – "I don't think I can even tell you this without some repercussion happening... Everything's already happened for me -- our daughter, our life together, our divorce..."

"What are you saying?"

"I just don't know what's already happened for you.-- Listen, Janosh, there are two ways you can go when your commander calls on Sunday, each one will create a new reality – the problem is that one way will lead to a disintegration of Life, and the other to a disintegration of Time."

In the con/fusion the train itself grinds to its next stop, and from here she leads me off and soon down a shadowy wooded path to a small bank on the edge of a stream.

"Is it much further?"

"We're here," she replies. "Just sit and wait."

I lean back, a foot away from her -- suddenly falling into a trance, unable to speak or move, though Najia is sitting up, turned away from me, her pajama blouse loosely fallen off one shoulder, revealing the side of her breast as she leans back against me, giving me the warmth of her body; she says "Do you remember being in this place once before, long ago.....?"

I am still perplexed by her attitude, but remembrance is coming, just as she said -- And slowly the ground in the space between where we sit begins to tremble, quaking deeper and deeper... Her face is still turned away from me as though unseeing---I'm trying to shout out, my voice refusing ---

I do hear my own voice shouting out her name...another Najia's form appearing behind her where the ground is shaking --- seeing me watching her, slowly overshadowed by another dim form of myself between us, the dopplegangers fading away into the ground, the two bodies of our love in the throes of naked passion, fading back

through the haze......

"Promise me we've made love before."

Yes.

prolepsis 43

Small twilight gathering in yard in view of the beach -- Najia,
Opal, and I walk out across the grass of the garden, and I am noticing
the sun as it sets in the southwest, across the water of Long Island
Sound.

As it drops lower in the sky, the sun seems to backlight the
horizon, and while I point this out to the others, pointing to the thin
strip of land on edge of the world, the sun sinks behind it, silhouet-
ting trees which must be fifteen miles away : It is the real intensity
of the Sun, the steady stream of energized photons from its continu-
ous nuclear fusion, pouring forth just like yellow syrup and sticking
to all the surfaces it touches, and electrifying the air with aurora
borealis... The scarlet limbs of silhouettes all the way over the water
on Atlantis – no, Long Island -- are branching across the dusky sky,
stretching up until they are almost over our heads, where I can see
an enormous albatross soaring far above in clear patches of blue --

From a radio someone is playing on the other side of the
lawn, I can hear Pop Music songs from the 1950's and early '60's,
which gives the day a festive air, but the station signal is nearly
fading out, and back in, with atmospheric static interference, so that
other radio stations are phasing in, now with a Beethoven symphony,

now with more raucous and dissonant chords of Post-Modern Rock music: I recall that the eleven year sunspot cycle is now at its peak.

Far inland from the coast the next noontime, I am alone on another errand for Xerxes, in light snow beginning the fall, already, in the chilly late autumn. The flakes begin to fall more heavily, covering my tracks behind me.

I glance at my watch and remember that Opal, Najia, and I were to watch the movie "A Christmas Carol" which was to be broadcast on TV this afternoon. I am supposed to be back at the beach house with the others, but I wonder on whose property I am lost in this blizzard.

The world slightly brightens as the black sky comes up to gray with the day's final light, as the sun is about to set, a yellow ball peering beneath the storm clouds, trailing shards of fractured light across the wide water.

But here in this context, making use of the remaining light, along comes Mr. Ebenezer Scrooge with two dog sleds and several of his strange looking henchmen, patrolling for trespassers, and before I can find my path again, I am discovered and caught.

Scrooge leaves two of his armed henchmen, one with a dog sled team who himself has a shaggy sheep-doggish appearance, to cover me and bring me in, while Scrooge goes on ahead back to the house in time so that he can watch the start of his movie on television.

On the way back, the snow becomes heavier and heavier, and my escorts more lackadaisical and further apart, so that I can then

pretend to trip, and then surprise and overpower the guard walking with me when his reflex tries to stop me from falling down. The other is out of sight and does not even hear our struggle. I take the sled and leave the first guard unconscious in a snow drift.

My sled gets moving just as Scrooge comes out to greet our arrival, but I suddenly realize that I know the actor who is playing Scrooge in the story – it's the face of Xerxes, but now revealing an insanity normally concealed behind his diplomatic facade…

I elude Scrooge and his other men by turning the sled on a path into a wooded ravine and running out across a wide tundra of deep drifting snow where the visibility grows poorer with the increasing winds.

Eventually, heading north into the storm, the sled passes an igloo-shaped snow drift, and I am distracted by a hole in the side of it from which emanates an intense orange glow. I stop to investigate the mound, cautiously coming into the entry of the glow of light.

But after a few moments, I can remember only the glow blinding me insensible within the igloo, an immensity of space and energy; then I am escaping again, and feeling an intense sense of invigoration. Now I somehow know to head to the west which brings my sled down the snow slopes into a small town I can see on the coast of the mountainside, a town unknown to me. Finally, at the snowline, I must continue on foot, letting the dogs go free and tipping the sled into the edge of a ravine, and I am soon walking through narrow winding streets.

Yet, I begin to hear the clear far-off drone of several motor-bikes which seem to have come in from the mountain trails behind me and now to be entering the streets of the town, where the sound becomes muffled by the walls of the narrow streets, as they pursue me.

Rounding another curve in the road, I slip into an empty garage, to elude them but realize that they are too close for me to close the overhead door before they will pass. As I hide, I wait for them to pass, but I am profoundly tired from this pursuit, and my eyes close by themselves and I am taken by an exhausted reverie – the sequence of the same descent into the town as in a dream, or embarkation, trying to find the docks in shady town streets near the harbor; but then out at sea in sunny warm air and waters speckled with light and colors; watching another identical ship moving parallel from west to east as we sailed east to west; I could see its passengers walking the decks of the other ship, people identical to us. Then the great ship we're aboard glided down the current faster and faster, now coasting down a mountain hillside around wide curves follow-ing along the graded slope— coasting downhill with such momen-tum that the large hull could barely negotiate the curves as the ship entered into the curved residential streets of a town, careening through narrow streets into an empty silent garage….

But here again, the sound of their motorbikes and dogs come closer and closer, until I realize that my pursuers have stopped direct-ly outside this darkened garage..

Out of breath and panting with fear, I try to hold my breath to escape detection, wondering who are these men who have pursued

me, feeling that they somehow know me, and where I've been. … I wait a time and finally peek out from behind the wall of my hiding place -- one of them is looking at me directly in the face, his weapon pointed.

They take me their captive again, though Scrooge is not with them now. I decide to speak to them and attempt to bargain for my life, telling them about the igloo I have discovered on the tundra, and the strange powers it seems to have given me.

To the henchman, with the unfortunate aspect of resembling a dirty sheepdog, I offer a dignified human character, and he grins with grotesque enthusiasm.

The lead henchman confronts me, a pirate character with sadly scabrous, mutated skin, wearing a patch over one eye, "Why are you running away from me? I hired you and gave you this assignment, and compensated you very well for your efforts…This has all been done to protect our country and our way of life…" Then I recognize the face beneath the pirate disguise as that of General Simone.

"Millions have died!! Was it accidental or did you know what would happen? Is your loyalty to your country or to the Angel of Death?" I protest. "General, everything that you have had me do has led to destroy Life. Now the only choice left was to unravel the continuity of Time -- but I've discovered another kind of power…" and I tell him, "You'll be able to transform yourself into anything or

any size you want! – Like a flea, you'll be able to land on the head of a pin!"

"What, not like an Angel..?!"

— Then out of the Blue the sky becomes
an orange-yellow flaring, screaming furnace vortex red chasm
of negative light,
 -- Hydrogen bomb Ground-Zero –

 nearby objects for a fraction -- silhouttes against the
 instant
 blinding
 Fusion FLASH of merging neutrons and protons / END.

Green Paradise

After I had been contacted by General Simone and instructed
to investigate the police reports coming from Paradise Green, I have a
peculiar sense of deva-vu when I arrive there I find an uproar of people,
standing around the wide sidewalk of the line of stores, staring west
across Main Street at the wide triangular Green. In the middle of the
widest end of the tree-spaced triangle are the same speckling lights as
vations.

Standing on the sidewalk, however, I ask various pedestrians
how long they have been there and what they have seen, but no one
here wants to offer any observations to anything so fantastic as what
is actually visible across the road, with the same quiet response from
each, "...I don't know..."

I cross the three lanes of Main Street to the lawn of Paradise
Green, attempting to get a better view before I decide whether to
approach the object -- The glaring luminous light flickers intermittent-
ly, shrouded by the tall pine trees, and I am filled with a feeling of a
fear that seems to come from an ancient and secret power ---

Steadily walking toward the object, shielding my eyes,
I think that I can see several figures standing upon its side. Getting

closer still, I am able to discern two figures standing on the dumb-founded as still unable to believe their transportation here.

But the three more Forms standing there are what I am myself hard-ly able to believe: Bathed in white radiance, I wait as my eyes adjust and withstand the glare: these Forms are garbed in silvery robes, their faces sparkling with dazzling colors, swirling in contours around four center points, one on each of their foreheads, two in the position of their eyes, and one at each throat.

One of them lifts his arm pointing for the human figures to go back with me, and they then seem to mentally transmit an incom-prehensible kind of greeting of spatial travelers and the warning and the gift of the "Splendid Lights"

"Witness the Radiance of the Seed within your own earthly skins---"

As I step aside and turn around as the figures slide from the oblong surface of the disc back to the ground, surprised at their abrupt-ly cheerful expressions, I glance back to see the light once more turn transparent and vanish from sight/

But as I am walking back home alone, down the first side street from Paradise Green east back towards the pond, I abruptly come upon a strange spot of pale green light on the road, which seems to hold in place before me as I try to move forward, as though tracing and checking my steps, the small pool of light of a beam of green light which comes out of the dark, starlit sky from a point almost directly above to the east, as though a ladder came down... The ladder of green light which recedes backwards from this spot and withdraws straight back over the black asphalt pavement of the next street and

slowly then up into the sky, while still scattering its fading green in speckles over the face of the quietly rippling water of Brewster's Pond, then dark..

This time I curiously walk closer to the spot of light on the pavement in the middle of the road, and this time I feel the beam of green light as solid, and taking another step forward, am drawn to walk upright on this beam of light, a ramp which has its own field of relative gravity, even drawing my body weight up quickly into the green radiance above the Earth and out into another Space/Time Continuum

…

Book Five

Nadir : a disaster waiting to be averted.

And then it was the next to last day, before the next
beginning of Time. Before, it seemed, there had been nothing but
dank overcast. No, really it was Anti-Time. . .

But that Sunday had been the last day of a sunny August
heat-wave, and a cold-front arriving overnight had seen Monday's
sky turn with chilled winds and waves of ice-cirrus coming over the
blue horizon, like waves on a beach suspended in time ..

What had happened that Sunday, while Hauberc still lived
with his parents for one more month before his wedding with Najia,
left a suspended experience in time. And Time kept advancing,
running out, moment to moment. Persephone and Carlos, Hauberc's
friends now living in Brooklyn were in town and Hauberc had
planned a particular experience for that weekend.

Hauberc's parents had gone on vacation to the Bahamas, the house entrusted to him and Juno.

Persephone, studying Law and Anthropology at NYU, and her recently married husband Carlos, a Physiochemistry engineering Masters candidate at Brooklyn Polytech Institute, had planned to come over from her mother's house to have lunch together when Najia arrived.

They had brought the massive New York Sunday Times newspaper and passed around the sections, reading quietly while they waited for Najia to arrive from Yalesville. Soon Hauberc and Najia would have their own apartment, with their own freedom, but new responsibilities.

Sitting on the carpeted floor in the doorway of the sunny afternoon den, Hauberc was looking at the colorfully printed Magazine Section when he felt a sudden release from mental gravity, which sent his body somersaulting backwards in free-fall through other rooms, by the startled faces of Persephone and Carlos:

"You say you can handle any mental dimension?" Carlos had dared him when they came over on Saturday morning: daring Hauberc to an experiment in the "laboratory of the self."

But this offer had so far been a disappointing dud (though Hauberc still waited)...

When Najia at last arrived at 1 o'clock, she coaxed Hauberc out for a walk, and they had gone down through the nearby streets to Brewster's Pond, and walked along the bricked-edge walkway around the wide, quiet suburbanized pond. They evoked a

romantic moment, as the reflections of light undulated in the water's soft sunlit surface....

...Rounding the curving high stone wall on their left, the walkway along the water came to the bridge over a tiny waterfall that they followed alongside, down the little stone steps into the tree grove of Longbrook Park below.

– But the idea of Nazi S.S. officers secreting themselves behind trees and stone railings abruptly shadowed his pleasure. Was that a past memory of something ? Or a vivid preview from the future ?

When Najia and Hauberc came back to the house, they found on the stove a large pot of seasoned Marinara tomato sauce which Juno had left slowly simmering, in preparation for a home-made ravioli dinner that she was preparing for them all for tonight. Had she gone off to spend the afternoon with her fiancé George? The house seemed quiet.

Some time later, as Hauberc happened to walk into the kitchen, he found Persephone and Najia standing at the stove, sampling
a spoonful of the tomato sauce:

"I think it needs some salt," suggested Najia, to which Persephone agreed and took the shaker to sprinkle some in. But the shaker-top came off and salt poured into the sauce. "Oh, no!" says Najia. "No, no," said Persephone as Najia in panic stirred in the entire tablespoonful.

At exactly Three o'clock, the telephone rang in the other room, and Najia came to tell him that someone named Mr. Simony wanted to talk to him.

When he took the call, General Simone's instructions were brief: provoke the underground cell to penetrate the Communications Reactor complex. "Do your friends have the device?"

Reluctantly, Hauberc admitted, "Yes."

"Tuesday midnight – Take over the Control Center. – That's an order."

Hauberc hung up the receiver very slowly: Just an order to end the universe... But this time another future self stepped into his mind to interrupt the cycle. This second chance was in Conscious Time -- *that was it*, he decided. He would change the tense of life from past to present : Hauberc would change from *he* to *I*...

Inaction now would change the universe, an alteration on Time. **Period**.

Four o'clock comes to find *me* (not Hauberc) lying sideways on the leather-cushioned, swinging glider on the screened sun-terrace, still trying unsuccessfully to peer into the inaccessible worlds hidden behind my eyelids... Juno had gotten the Bridgeport Sunday Post and I was looking over the funny papers – the brightly colored Prince Valliant strip in particular, made him ponder over the passe' ethic of Chivalry. Uncle Simone could go to hell !

His ilk assuredly would go there anyway. But as to his own dilemma: he would go through with it, getting married. He was in

love too, but didn't understand this principle of the formality... ?
The wedding was only two weeks away.

An idyllic mood had settled over the afternoon:
Persephone and Carlos were sitting quietly together at the other end
of the terrace, quietly talking.

Even a bowl of hashish did nothing for me, and *I*
meanwhile puzzle over my own *still*, unnatural,
supernatural calm...

Najia, almost floating in the air, finally comes out onto the
terrace to find *me*, to sit at the other end of the glider sofa on which
I sit, leaned up against the end cushion. She sits with her feet on the
floor, ready to curl up with me, and begins to playfully rock me in
the glider back and forth, faster and faster, until I'm dizzy.
"Please, stop! Please.." I try to tell her as my brain
tumbles, and I feel my last crisp sense of equilibrium *cascade over
a waterfall*.
But smiling and innocent, she speeds the glider on, the
cascade rushing with more and more *images and emotions of a tidal
flood over me*, finally bursting apart inward over me massive pieces
of the Wall of the Dam... The dam of consciousness which holds in
the resirvoir of the Subconscious!

Downstream, carried through rooms of streaking anxiety, I
struggle to remain afloat in my mind, the flow finally widening out

where bubbling schizoid music strains, Schubert's *Arpeggione*.
"Hey, Carlos....!" I try to tell him.

"Quit listening backward, Yanush!" Carlos interupts, shouting back at me in an annoying loud voice over the music playing on the living room stereo, "check these out, man!" he rants, coming over to the to put the LPs he's brought over onto the record player, new record albums I haven't heard yet, "Listen to these new Stones and Doors, just out ! Dig these lyrics, man, they're saying *we* didn't create this Reality mess – but we can break it.

"Break the Cycle!"

Near his bus transfer in the record shop in Bridgeport on Fairfield Avenue near Main Street, on his way home from his factory job, two months after he returned from Europe, Hauberc had already discovered The Doors' first album, just after its release, attracted by their rendition of Kurt Weil's *The Alabama Song*, and references to William Blake.

The Rolling Stone's had released "Their Satanic Majesties Request" which the music critics labeled the group's response to "Sergeant Pepper's Lonely Hearts Club," but Hauberc could hear was radically more ground-breaking. The song *Citadel,* seems to paint the whole 20th Century, by the rhythm of the hammer on the anvil: "In the streets of many wars/

Hear the panzers come and crawl/ You can hear their numbers call..."

But I begin to see that there is still no way out for me, tomorrow or the next day, that all actions must follow their course, not as pawns, but like spokes in the Universal Wheel, eternally doing what everyone else wants. Fuck it!

Another one Carlos plays for me is a new Doors song I've never heard, called *The Lizard King* with a reference I recognize from Frazer's *Golden Bough* concerning the taboos restricting the Mikado's physical movements to his throne: not allowed to touch the ground under immediate pain of death: "NOT TO TOUCH THE EARTH/ NOT TO SEE THE SUN/ Nothing left to do but Run, Run, Run/ LET'S RUN!"

...And then the disastrous terror: "Dead President's corpse in the driver's car/ The engine runs on Glue and Tar/ Come on along -- We're not going very far/ To the East/ To meet the Czar..."

With our young President blown apart in Zapruder Technicolor, our young hopes for peace and justice were killed by what Dark DEMI-URGE ? And now, not even 3 months ago, his younger brother, campaigning to introduce World Peace, was cut down by another assassin, who, when thrown into his cell, asked for a copy of Madame Blavatsky's *Secret Doctrine* to keep him company. But the Demi-Urge kept saying "there's no Conspiracy!" -- not even a Theory!

Morrison's lines: "What have they done to the Earth? What have they done to our fair Sister?

"Ravaged and plundered, and ripped her and bit her, tied her with fences and dragged her down!"

Now we can only bring back the Light from inside the Dark tunnel -- take the path into the dark Abyss looming ahead in the emptiness of future Time. Like Novalis wrote, "Take the Light as a weapon down into the camp of the Dark Army." Hauberc had started a diary of his nighttime dreams while a senior in high school, which while in Europe, had turned into a nightmare scenario of nuclear apocalypse, a novel in the works of surreal desolation, still looming a potential reality.

Finally, after Persephone and Carlos have left to head to their summer cabin in the woods of Sandy Hook, Najia has put a Vivaldi record on the turntable, and this energized music comes in and out of focus in Hauberc's brain, circling the soul caught in an eddy
Each note of the harpsichord forms a color, a *hue*, and a harmonic *tone*, red, green, blue, soft yellow, purple... The underlying drone line of the continuo slows down into a tonality of fullness, of full extension of Time, as I am trying to slow down the pace of my brain, sitting before the stereo-speakers, the long motion of waiting and reaching the end of the spiral, where the arid desert has already grown into vastness around my postural self, focused to an infinitesimal point...the layers above me glaring and scintillating with the celestial Harmonics that shimmer through their (our) Mercurial bodies' silhouettes/sitting on the wide empty plain ...

All of life scatters back into focus.. as we are sitting in the kitchen, time later, my sister and her fiance, and I, around an unpretentious dinner table, a semi-circle with the wall:

I'm wondering why Najia has not come to the table yet, as though leaving me out here wondering how -- and whether to -- explain myself in this state of mind to my naïve little sister. As Vivaldi's *Four Seasons* slowly comes to its end. I think of the 2/3 pun of *"Four Seasonings"* hoping that the salt shaker hasn't destroyed dinner.... Now The Doors music comes on the record player again, and I see Najia's face peeking around the corner of the living room passage, as the Doors are singing "The face in the mirror won't Stop/ The Girl in the Window won't drop! / A Feast of Friends -- ALIVE! she cried, -- Waiting for me -- OUTSIDE !!"

"Please pass me more salad, " says Juno... I am hauled back to mundane reality.

"I can't wait to try your Ravioli..." says George.

Looking at everyone's face I immediately forget just why I am afraid even to look up from my dish, as the main course is brought to the table; my own physical tableaux running concurrent with the bizarre fancies which sketch across my field of vision -- then seems to dive so deep in an instant like a high diver above the pool : a plane of green stillness is there again, in the temporal moment: a soul of love is there, I can see it in her face... But I realize I am so weak that the surface I am on begins to cave in, cave in onto the surface of this moment..

A closing tightness of myself, still surrounded by silence---

"What's the matter with the ravioli, Juno?" asks George.

"I'm not sure," she responds quickly, nervously, as I am becoming acutely self-aware of the strange and incomprehensible process with which I am putting food into my physical form...

Beside me, the table conversation is becoming increasingly self-conscious among the silent participants, the mental questions of imagined failure, disappointment and blame rapidly seem to take on looming and echoing effects ...

"Taste's salty," says George. But a looming self-conscious monster stands confronting me, and the overwhelming mineral echo of sodium through me causes me to jump to my feet and speechlessly run from the room: never hearing, never knowing the words or the consequences about my ensuing spatial void---

After a long time alone, hours, years, perhaps moments, I am joined sitting on my bed as I stare from the window... "What's happening to you?" Najia asks me softly, taking my hand in hers. But I simply look down.

"Come, the tide is going out..."

She takes me by car through the streets of amnesia, of sunlit shadows and viaducts, over a river of opaque currents, over the bridge to Milford, through motionless-rapid pictures of another town's streets, and eventually out onto a sandy beach shore-line where she and my-selves arrive walking hand-in-hand, she and I hand-in-hand, pausing at the end of the long rocky land-bridge at the

edge of Charles Island, a spot where Captain Kidd once combed the sand and hid his treasure --

But as soon as we reach the island, we must turn back toward shore: the dimming sky, the returning tide waves slowly washing back over our path behind us -- beneath huge Pentacle stars hanging in the twilight above and the brilliant moon-crescent looming over us, flashing on-and-off still with daylight brightness...

Walking up the stairway, returned and into my own bedroom, the now-fallen darkness pierced through the window over my backyard, bombarded by yellow-sulfur light-photon bolts from the neighbor's yard lantern (over the lilac trees) --- bursting before my window:

black kaleidoscope shadows spiral apart / childhood's clipper-ship rigging on the wall

as my eyes spiral apart upon the hesitation of an undressing vision, turned aside, the side of a face, a shoulder, a naked breast, an arm...

We come down close together, our bodies on the narrow bed, seeing, gently caressing the tenderness of limbs kissed with the lips ... already triggered with love -- Heat rising in the small spaces left between two bodies, those sights yet desired, her inner prickling folds of skin, the tiny bud heated, became moist to his touch, then to his lips ... a flame to his nostrils

... the fullness of his blood's organum to her hand's pliant grasp --

skin slides along skin --

262

friction -- we climb, together, up into a raptured sky, into a
weightlessness of passion's fathoms...

: here : we are two natives of this Compendium -- naked etheric
floating forms --- this was a planet of a long bloody history; an
Ocean of Occurrences : the Backwash of
Time, (river bore of prophesy)
And I saw the heavens open, and behold a great white steed,
and He that sit upon him doth judge and make war....(

opposing cavalry armies charging like history, swords
flashing, horse soldiers converging
in battle. . . .)
His eyes were aflame of Fire, and on his head were many
crowns, and he had a name written, that no man knew but he
himself....
And the armies from the heavens
followed him upon white horses
And out of his mouth
goeth a sharp sword, that with it he should smite
the nations.....

Abridgement: the whole world naked, we raged at
each other, gently, passionately, silent into battle, met there
our warriors
complete
And our warriors one hath slain the other, and

consumed him, a Eucharist of flesh and blood

-- And Finally, we come to sit up in a mutual embrace,

crying to one another

a communion of joy

And when they went up on

the breadth of the earth, and compassed the beloved city

about: and fire came down from God out of the heavens,

and devoured them.

Primordial man, retreated

into the darkest jungles of the earth...reveled in the

Glory of the Divine Sustenance...

And I John saw the new holy city,

coming down from the heavens.......

And all their Tears shall

be wiped away from their eyes; and there shall be

no more death, neither any more pain : for the former

are passed away.......

And let him that is athirst come, and let him

take freely the water of life....

Laterness of I's past,

in the dark we are looking from the foot of the bed out the

window at the throbbing lantern-light through my neighbor's yard

trees...

In the dream of my heart, I go walking through the subdued

glow of a Moorish archway, to where jewelled tinkling water
droplets come falling from spout to tiny porcelain pool...flowing
liquid coolness through hands, over faces, listening within the
fractures of fluorescent quartz mirror reflections, layers come away
to escape through fingers,
echoing beads prism away...

Returned together down thru midnight
darkness to the glider on the screened terrace -- outside : the warm
slow songs of ten thousand summer night crickets---
Limbs soft against limbs, skin against skin, we sit in our
quietude, gazing into one another's eyes ...
We've tip-toed downstairs, naked, sexual, and defiant out into
the open terrace darkness
of these surrounding suburban houses, the tall azalea
shrubbery concealing us here,
curled together lying on the leather glider sofa, sipping
fresh orange-juice of the sun-fruit, the glimmer of a distant yellow
street lamp glowing and revealing our faces and supple limbs for us
to gaze at one another's surreptitious sumptuous
nakedness...

but the sky still strobes with super-novae flashes of stars
confusing my eyes through the trees of wire branches and shadow-
petal leaves ---
the reflective images of fantasies and Time-

Liquid Hopes : wandering gaze through each other's
eyes. . .
our happiness moving on and on and further on...

And on in above (upstairs) bedroom once more,
bed, body, lovers, stampeding into Satori..."You can again?"
she inquires..."Then Let Yourself Come Inside my Heart,"
she says, then, joined, the motion of skin within skin, soul within
soul,
until the volcano erupts /
she asks, "What's happened?"
...as an immense orange and yellow incendiary Burst casts
over our vision a Baptism of Flame ...

Over me : (now falling into repose)--- the smoke of this
physical explosion slowly clears away, revealing its source above...
as I gaze on a *Wonder* -- a vision of the Stroke which opens a
Doorway
into Life : *the silhouette of a cross-shape* burning through a black
Wall of Energy... beams of the Pure Light flooding in, through the
Fissure from without, refracted in through the residue smoke...

stop world time --- I lay back slowly down, listening
to curious pulsing sine-waves that I perceive -- the harmonic
sounds of my body limbs which I slowly lift and lower to discern ---

"Did you see it happen ? – This is our hope for the world,
John ..."

she whispers.

(I) travel instantly to remote cosmos
(the space-time-energy grid of my Eternity of Lives, my
karma re-seeded, contracted to this one neural vortex) ---concentric
warp,
then like a tangent, my astral shell a vector arriving
sonic-resonant against other dimensional walls...
Echoing capsules of me ricochets away, back into here...
Ringing; schizoid cadences, fuzzing electric
filaments of music path my neuron synapses.
...Terrestrial Creatures these (--my human race to be)...

Once Space-men touched the Earth... not to be denied the
concreteness of reality,
they would arrive and depart from each world,
the Transportation of Redemption.
(these many strange beings that I have seen to walk in the
mid-day market bazaar).... inter-galactic merchants of the Avaricious
dream:
Pictures of
turmoil yet remain---Sons of Darkness yet remain here---
For we wrestle not against flesh and blood, but against
principalities, against the world-rulers of the
darkness, against spiritual wickedness in high places...

(Radio-heterodyne) transceivers of the force fields---

these were chalices of the flesh

Awake, I remain now

piecing together broken relics of the amnesiac world,

and she sleeps...

The Mind would scatter yet through the radio Static and

Harmonics of all possible remembrances,

the Circus Maximus of all ancient lost contacts,

stretched bodies, moistened skin,

(Radio-Regenerative hiss)

listening Forms of-the/to-the Space/Time Parity. For in

my heart-self I knew now what was truly to Come :

but that the instantaneous Light could pre-empt even

prolepsis ...a Disaster Waiting to be Averted.

The Will (that lined history) opposed the Subconscious sea;

the Menstruation Envy of the battlefield must needs itself to prevail,

all would inevitably die: --

But a Truer War was fought upon this softer stage.

the darkness half of night, open passage

of the picture stream

wherein all beings dance, demons prattle,

and angels cry :

"oh, sweet peace of dreamless night"

"hold your enemy within your arms---"

"no *joy* was ever so forgotten"

And slowly, the sky turning from

deepest violet to orange-blue---heliocentric

spirals unreel . . .

The unsleeping body's quiet electri/city

until the dawn's green-blue and pink rays light my sleeping

lover's childlike face, trickling silverdust

over all the hollows and ridges of skin

...the gold breath spinning into her hair,

tossled on her pillow

CPSIA information can be obtained
at www.ICGtesting.com
Printed in the USA
FFHW020707200319
51141171-56604FF

9 780990 925767